IMAGES
of America

YOUNGSTOWN

To Heidi —
Thank you for all your
help — especially at
crunch time!
D

8 October 2013

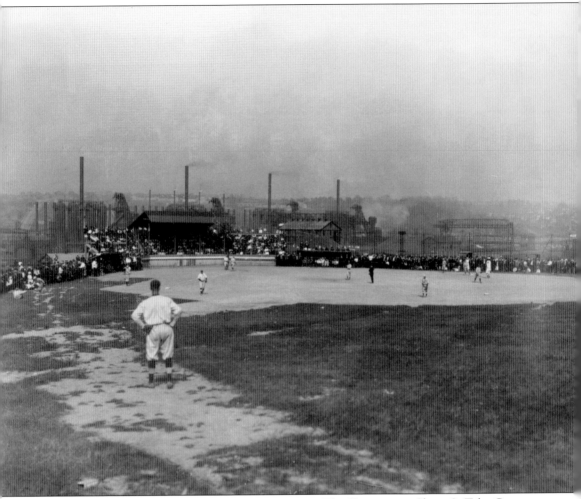

YOUNGSTOWN SHEET & TUBE COMPANY BASEBALL. The Youngstown Sheet & Tube Company baseball games were usually played at Campbell Park, overlooking the steel mill. This 1926 image shows a game in progress. Note the ever-present smoke from the mill.

ON THE COVER: OHIO STEEL COMPANY MACHINISTS. Founded in 1892, the Ohio Steel Company began operations three years later. It was the first facility in the Mahoning Valley to use the Bessemer process, the revolutionary method of mass-producing steel developed by Sir Henry Bessemer in 1856. The Ohio Steel Company, through various acquisitions, became a part of the Carnegie Steel division of US Steel.

IMAGES
of America

YOUNGSTOWN

Donna M. DeBlasio

ARCADIA
PUBLISHING

Copyright © 2013 by Donna M. DeBlasio
ISBN 978-1-4671-1091-4

Published by Arcadia Publishing
Charleston, South Carolina

Printed in the United States of America

Library of Congress Control Number: 2013937854

For all general information, please contact Arcadia Publishing:
Telephone 843-853-2070
Fax 843-853-0044
E-mail sales@arcadiapublishing.com
For customer service and orders:
Toll-Free 1-888-313-2665

Visit us on the Internet at www.arcadiapublishing.com

CONTENTS

ACKNOWLEDGMENTS

Many people deserve my gratitude and thanks for their help in creating Images of America: *Youngstown*. The work started last year when I received a research assistant through the generosity of former Youngstown State University dean of graduate studies and research Dr. Peter Kasvinsky. I had the good fortune to hire Arielle Lester. I gave her the task of starting to go through the photograph archives of several local institutions, with somewhat vague instructions to find suitable images. Arielle did a great job; she selected the great majority of the images found in this volume. I also need to thank graduate student Heidi Summerlin, who was so helpful as I stressed out trying to find the images that needed to be rescanned or replaced.

I would also like to thank the dean of the College of Liberal Arts and Social Sciences, Dr. Shearle Furnish, who granted me a course release to work on this book. Of course, no pictorial volume could succeed without the help of the archivists who care for these images. I would like to thank Pam Spies of the Mahoning Valley Historical Society (MVHS), who worked with Arielle in going through their marvelous visual collections. I also thank MVHS director Bill Lawson for granting permission to use their collections.

Martha Bishop of the Youngstown Historical Center of Industry and Labor archives/library went beyond the call of duty on this project. She worked with Arielle on the initial triage and scanning and tolerated my going through the collections and interminable requests for scanned images. The last weeks leading up to the deadline were particularly hectic, partly due to an unexpected flood in the archives. Nonetheless, Martha was a trooper, and this book would not have become a reality without her. I cannot possibly thank her enough.

I am also grateful to my family and friends. You all keep me sane and put up with my affection for this place I call home.

Finally, thank you to Youngstown, my hometown. This place has a way of getting under your skin. It is my good fortune to be able to chronicle some of Youngstown's fascinating history.

Unless otherwise indicated, all images are courtesy of the Ohio Historical Society: Youngstown Historical Center of Industry and Labor.

The author's royalties will be divided between the Ohio Historical Society's Youngstown Historical Center of Industry and Labor and the Mahoning Valley Historical Society to further each agency's mission of preserving our history.

INTRODUCTION

For most of the 20th century, Youngstown, Ohio, was known as the "Steel City." The industry permeated every aspect of life in this community. Nearly every resident had some connection to steel, either working for one of the steel manufacturers, running a business that relied on the prosperity of the industry, or operating essential services. The mills, which were huge facilities, dominated the Mahoning Valley's skyline. From early in Youngstown's history, the ferrous industries seemed to be a natural fit.

The first blast furnace west of the Alleghenies—the Heaton, or Hopewell—began operations in 1803. These early furnaces were stone stacks, built into the side of a hill so they could be more easily loaded. The raw ingredients necessary for the production of pig iron—iron ore, limestone, and carbon in the form of charcoal—were readily available in the area. When the Heaton furnace went out of blast in about 1812, James and Daniel Heaton moved their operations farther up the Mahoning River to what is now the city of Niles. They later built a stone stack furnace in what is now Mill Creek Park on Youngstown's southwest side. These early furnaces survived as long as the raw materials lasted. They were also fired by charcoal, not coal.

The production of charcoal, which required vast amounts of forestland, was also very labor intensive. While the British began using coal to fire their blast furnaces, in the 18th century, the Americans, who had immense forests in North America, were slower to transition. In the Mahoning Valley, the discovery of a type of coal that did not first have to be coked (the process of removing impurities from coal) before using in the blast furnace spurred the area's iron industry before the middle of the 19th century.

By the time of the Civil War, there were many local concerns that manufactured iron. The development of the railroad industry kept these companies busy day and night, even when local supplies of raw materials became depleted. Although iron production came of age with the railroad industry, steel proved to be more durable, flexible, and versatile than iron. Invented in 1856 by Englishman Sir Henry Bessemer, the Bessemer converter was the first method of mass-producing steel. The ability to produce steel inexpensively revolutionized the industry, contributing to the expansion of the industrial revolution. Steel provided the infrastructure for tall buildings, rails, and consumer goods like automobiles, dishwashers, and washing machines, all of which transformed daily life. Andrew Carnegie opened his first steel mill, the Edgar Thompson Works, in 1875, thus setting the United States on the road to eventually dominating the industry by the early 20th century.

The Mahoning Valley, however, was a latecomer to the production of steel. The Ohio Steel Company formed in 1892 and, in 1895, began manufacturing Youngstown's first Bessemer-process steel. A number of new companies formed for the manufacture of iron and steel, including Republic Iron & Steel, the Youngstown Sheet & Tube Company, and the Brier Hill Steel Company. Many smaller concerns were victims of consolidation; for example, the Ohio Steel Company eventually became the Ohio Works of Carnegie Steel, a division of US Steel. By 1923, three major firms

dominated the Mahoning Valley: Youngstown Sheet & Tube, Carnegie Steel, and Republic Iron & Steel. These three corporations, along with their various subsidiaries, employed thousands of people throughout the area.

The manufacture of steel changed the nature of work in the industry. Steel required thousands of workers, many of whom were unskilled. Iron concerns were usually smaller and employed more skilled and semiskilled employees. The puddlers, heaters, rollers, and other highly skilled iron makers had far more leverage with management than the mass of unskilled labor. It was much easier to replace unskilled workers, so there was little incentive for the mass of steelworkers to join a union. Although there were several strikes in the Mahoning Valley, including two massive walkouts (one in 1916 and the other in 1919), the majority of steelworkers remained unorganized until the 1930s. The rise of industrial unions forever changed workplace relations for the industry. The industrial unions, including the United Steelworkers of America, ushered in the era of collective bargaining that greatly improved working conditions and increased salaries and benefits, all of which created a strong middle class in post–World War II Youngstown.

The growth of the steel industry in Youngstown led to a dramatic increase in population from 45,000 in 1900 to 170,000 by 1930. Men and women emigrated from southern and eastern Europe, greatly enhancing the diversity of the region. African Americans also sought new lives here as they left the South for jobs in the mills. Steel was a magnet for people from other parts of the globe as well. The arrival of such diverse people gave the Mahoning Valley its rich ethnic flavor. From local foods like Brier Hill Pizza to the famed cookie table at many a wedding and from the dozens of festivals celebrating our many cultural traditions to the various different houses of worship that dot the landscape, Youngstown reflects its diverse heritage. Without the lure of a better life offered by the steel industry, this area would not be home to such rich cultural traditions.

The wealth created by steel also gave the community its many lasting institutions. In fact, the very presence of industry led Volney Rogers to preserve one part of the city as a natural wonder, and Mill Creek Park was born. Industrialists supported community treasures like Stambaugh Auditorium, Youngstown State University, the Public Library of Youngstown and Mahoning County, and the Butler Institute of American Art. The desire to provide amenities for the entire community led entrepreneurs to build Idora Park, movie palaces like the Warner and Paramount Theaters, golf courses, swimming pools, and playgrounds. For a city its size, Youngstown had much to offer its inhabitants.

This volume of Youngstown images centers on the incredible impact the industry made on this community. This once mighty force defined Youngstown and its people. My own family, like so many others, had some connection to steel. One grandfather worked at Youngstown Sheet & Tube, the other was a stonemason who often laid refractory brick in those very same furnaces, and my mother was a "Rosie the Riveter" during World War II at Truscon Steel. This volume is dedicated to all the people who called—and still call—Youngstown home.

One

BUILT ON STEEL

The iron and steel industry arose in the Mahoning Valley because of the natural resources that were readily available: iron ore, limestone, and trees for charcoal. In 1803, brothers James and Daniel Heaton constructed what is believed to be the first blast furnace west of the Alleghenies in what is now the town of Struthers, just southeast of Youngstown. From this beginning arose an iron and, later, steel industry that was second only to Pittsburgh in the total annual tonnage of pig iron produced. By the mid-1920s, the area was home to three major steel companies: Youngstown Sheet & Tube, Carnegie Steel (US Steel), and Republic Iron & Steel. Together, these large facilities employed tens of thousands of workers. While these images capture the essence of the steelmaking process, they do not convey the immense size of the equipment and the spaces required to turn iron ore into a useful product. Although Youngstown was an iron-producing region throughout the 19th century, it was steel that defined the area through both prosperity and depression.

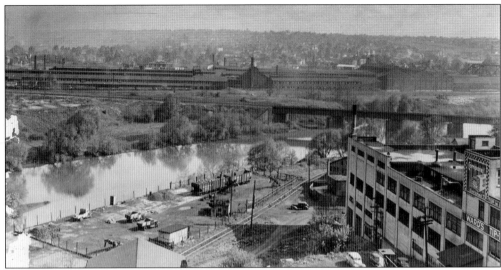

UPPER UNION MILLS. Located on the northwest side of Youngstown, the Upper Union Mills were a part of the Union Iron & Steel Company. Formed in 1892, Union Iron & Steel was the product of the merger of several local iron firms, including Cartwright, McCurdy & Company, and the Youngstown Iron Company. National Steel bought out both Union Iron & Steel and the Ohio Steel Company in 1899, operating them under the American Steel Hoop Company.

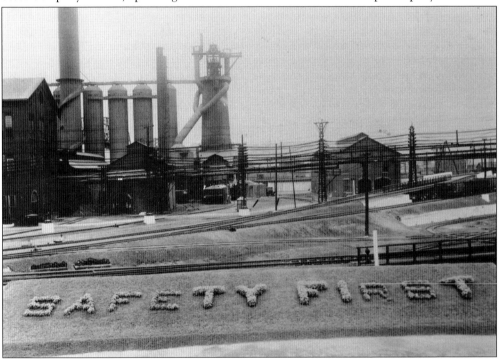

OHIO WORKS NO. 1 BLAST FURNACE, 1916. In 1901, Andrew Carnegie sold his company to financier J.P. Morgan, who consolidated all of his steel interests into the US Steel Corporation, the world's first billion-dollar concern. In 1903, American Steel Hoop and National Steel were absorbed into Carnegie Steel. The Youngstown facilities were known as the Ohio Works of Carnegie Steel. In 1936, the name changed to Carnegie-Illinois Steel.

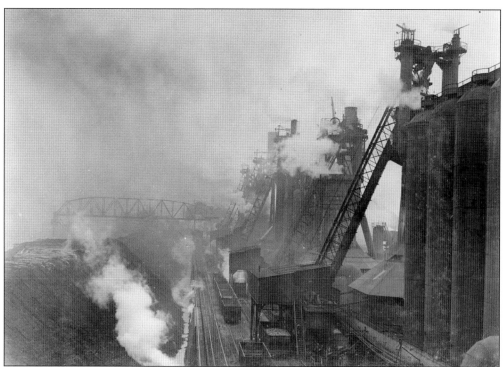

BLAST FURNACE AND COOLING SLABS. One year prior to the creation of US Steel, American Steel Hoop poured money into its Youngstown facilities. The new giant corporation, US Steel (often referred to as "Big Steel"), merged other companies such as American Tin Plate, National Tube, and American Sheet Steel. Federal Steel, which was owned by Judge Elbert H. Gary, was also an important component of US Steel. The size of the corporation alarmed many Progressives who were wary of such trusts. There were efforts to break up US Steel, contending it was in violation of antitrust laws, but they were to no avail. For many years, the company controlled more than two-thirds of American steel manufacturing. The image above is one of the company's blast furnaces. Below, slabs that were produced from the 40-inch mill cool before going on for further processing.

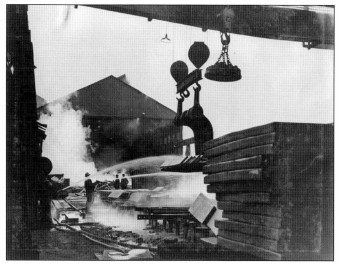

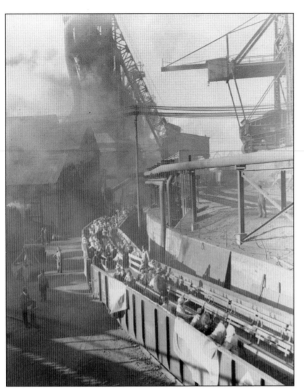

CARNEGIE STEEL OHIO WORKS LINE. Carnegie Steel operated several facilities in the Mahoning Valley. Besides the Ohio Works in Youngstown, the company also built finishing mills farther up the Mahoning River between Youngstown and Niles. Because the new facility was at some distance from settled areas, the company built a town adjacent to the mill. The community was named McDonald, after the Ohio Works superintendent Thomas McDonald.

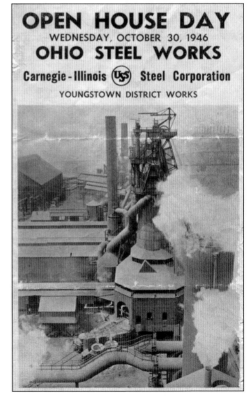

CARNEGIE-ILLINOIS STEEL OPEN HOUSE PROGRAM. In 1946, following the end of World War II, Carnegie-Illinois Steel held an open house at its Ohio Works facility. The end of the war meant that consumer goods, many of which used steel, would once again become plentiful. The well-attended event was meant to show off the company's facilities and its postwar products.

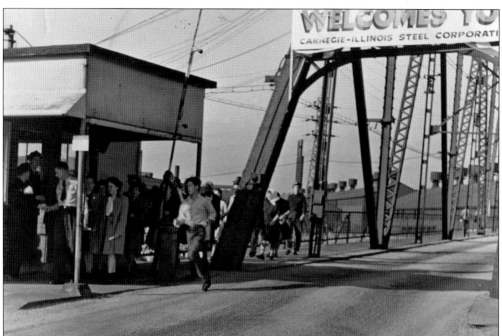

CARNEGIE-ILLINOIS STEEL WELCOMES YOU. Carnegie-Illinois Steel was anxious that the families of its workers be welcomed into the plant, and buses transported men, women, and children from the parking lot to the facility. They even loaded people into trains and rode them around the grounds of the mill. Once inside, visitors were given the grand tour as the company proudly displayed its equipment. Note that the visitors are not clad in safety gear; women are even wearing heels. Management clearly did not intend to bring its guests into the more hazardous parts of the mill.

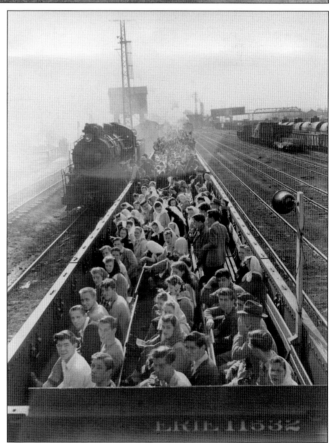

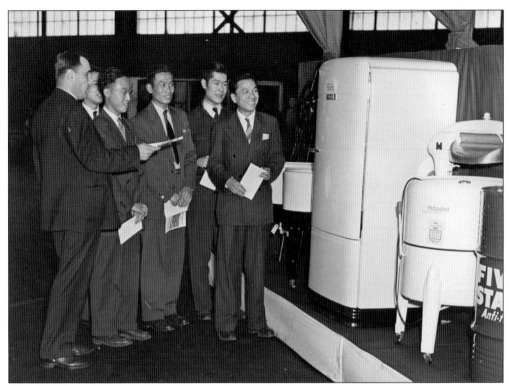

CARNEGIE-ILLINOIS STEEL PRODUCTS. Following the shortages of consumer goods necessitated by war production during World War II, Carnegie-Illinois Steel proudly showed off products made from steel that were now coming back onto the market. Every housewife needed a new refrigerator, washer, or another domestic appliance. During the war, Americans did without many of the products that are now common in most homes, as steel was needed for war materials. Once the war ended, American industry retooled, and automobiles and other consumer goods once again became available. The postwar generation was ready to spend money on themselves and their families.

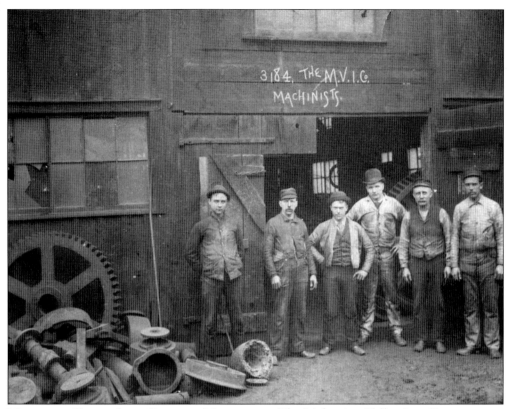

MAHONING VALLEY IRON COMPANY MACHINISTS. The Mahoning Valley Iron Company was founded in 1895. A short-lived venture, it was absorbed by the newly formed Republic Iron and Steel Company in 1899. Republic was a combination of several extant iron- and steelmaking facilities located in the Midwest and South. In Youngstown, besides the Mahoning Valley Iron Company (MVIC), it also absorbed Brown, Bonnell & Company and Andrews Brothers & Company. Seen here, the machinists for MVIC are, from left to right, Frank Seitz, Harry Winters, Robert Solomon, Joe Roberts, Spence Bradford, and John Solomon.

REPUBLIC IRON & STEEL COMPANY, 1919. This aerial view of the Republic Iron & Steel Company shows the facility hugging the banks of the Mahoning River. Republic extended east from the Market Street Bridge almost to the city of East Youngstown (now Campbell) and was adjacent to the flagship plant of the Youngstown Sheet & Tube Company.

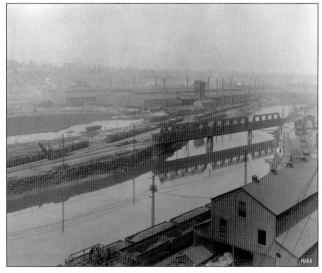

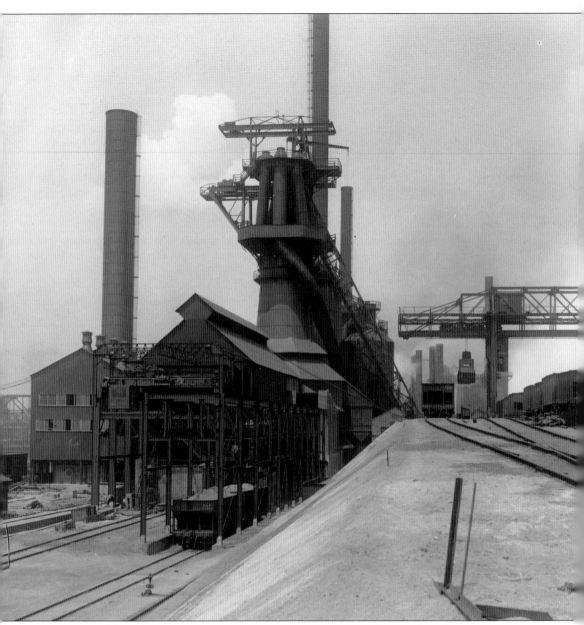

HASELTON NO. 5 BLAST FURNACE. The first process in making iron and steel takes place in the blast furnace. Workers load skip cars with the raw materials that are then hoisted to the top of the furnace. The coked coal, iron ore, and limestone are used to load, or charge, the furnace. Air that has been heated in the stoves adjacent to the furnace is blown in at the bottom, allowing the chemical reactions to occur. The limestone is used as a flux to remove the impurities from the smelted ore and is siphoned off in the form of slag. The molten pig iron is then processed into iron or steel products. This is Republic Steel's Haselton No. 5 Blast Furnace, named for the eastside neighborhood adjacent to the steel mill.

REPUBLIC STEEL COKE PLANT. Most of the coal in the United States is bituminous, or soft, coal. Before the coal can be utilized to fuel the blast furnaces, the impurities must first be removed in the coking operation. Around 1900, Republic Iron & Steel began construction of its coke plant, seen here.

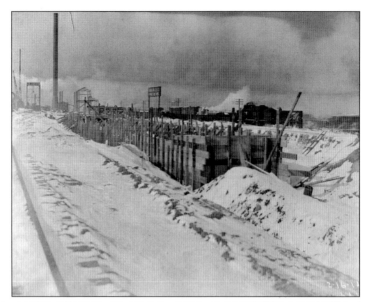

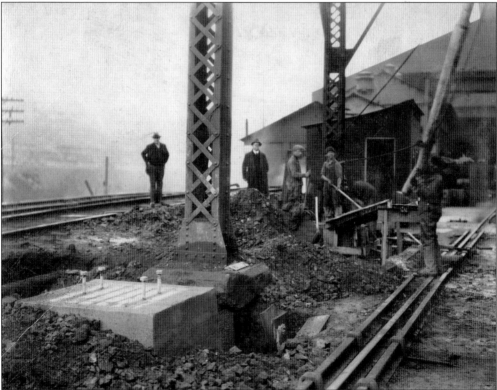

REPUBLIC IRON & STEEL BESSEMER CONVERTER. One of the first upgrades that Republic made to its Youngstown facilities was the construction of a Bessemer converter in 1900. Although the company used the term "iron" in its name, within five years, it eliminated the puddling operations from the Youngstown plant. Puddling was one of the first processes used to make bar iron. The puddler, who was a skilled craftsman, stirred molten iron in a reverberatory furnace, after which the iron was sent on for further processing.

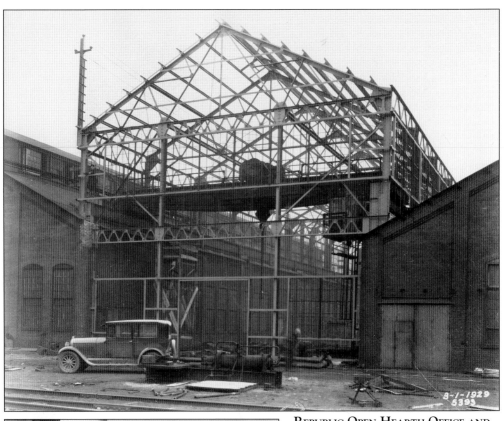

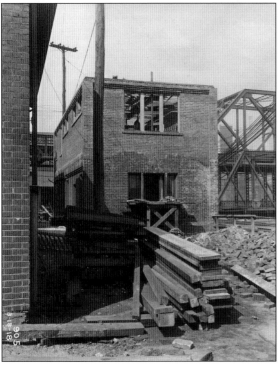

REPUBLIC OPEN-HEARTH OFFICE AND HOSPITAL. The open-hearth process for mass-producing steel appeared as a contemporary to the Bessemer converter. Known as the Siemans-Martin process, the open hearth complemented rather than replaced Bessemer. It takes longer to convert a batch of steel in the open hearth, but this allows for greater control and the production of different types of steel. The open-hearth office building seen above and the hospital to the left served the needs of those who worked in that department.

REPUBLIC STEEL OFFICE BUILDING. In 1911, Republic erected a new office building adjacent to the Market Street Bridge, seen here under construction. In 1929, industrialist Cyrus Eaton merged four major companies to create the Republic Steel Corporation. Between 1928 and 1936, Republic acquired several more operations in the Mahoning Valley, including Trumbull-Cliffs Furnace in Niles, Trumbull Steel in Warren, and Truscon Steel in Youngstown. In 1936, Republic officially moved its headquarters to Cleveland, Ohio.

REPUBLIC STEEL INGOTS. After the pig iron is transformed into steel in the open hearth or Bessemer, the next step is to pour the steel into ingot molds. Once the ingots have cooled, they are sent on for further processing. This 1913 image shows ingot molds at Republic Steel awaiting the hot metal that will be poured into them.

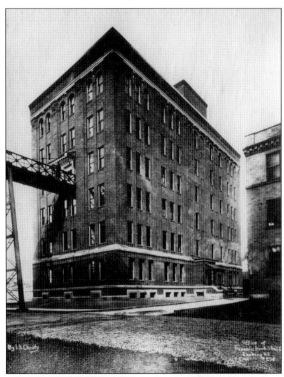

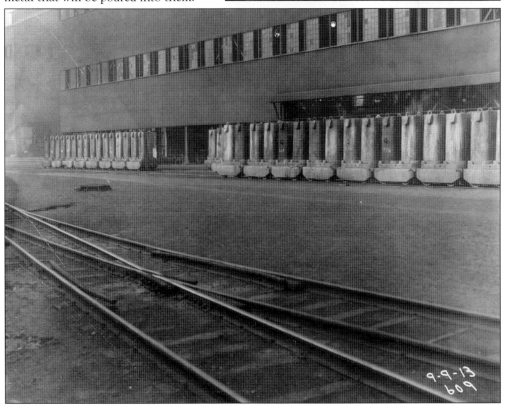

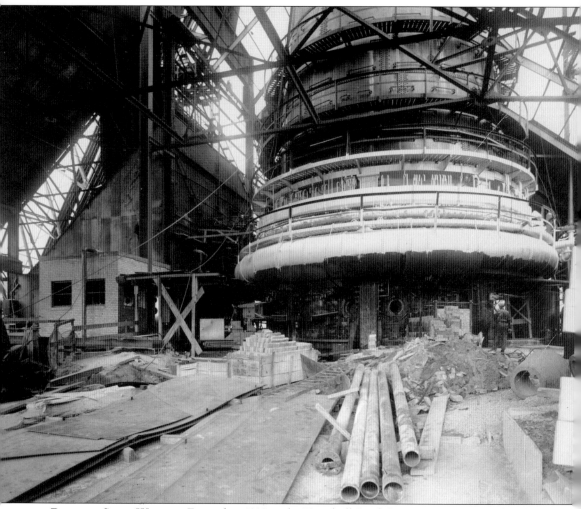

REPUBLIC STEEL WARREN. Formed in 1912 as the Trumbull Steel Company in Warren, the plant began operations the following year. When the new blast furnace opened in 1922, it was the largest in the world and had a 60-ton daily capacity. Absorbed by Republic in 1928, the facility was known as Republic Steel Warren District. In 1968, Republic consolidated its operations with the Youngstown plant to form the Mahoning Valley District. During the wave of steel mill closings in the late 1970s and early 1980s, Republic merged with Jones & Laughlin Steel, and both became a part of the LTV Corporation. Between 1988 and 2012, the facility changed hands several times, with ownership transferring from Renco Group to Severstahl and finally to RG Steel (the result of the reorganization of Renco). RG declared bankruptcy in the spring of 2012, and the Warren facility was closed. Seen here is a blast furnace under construction in 1939.

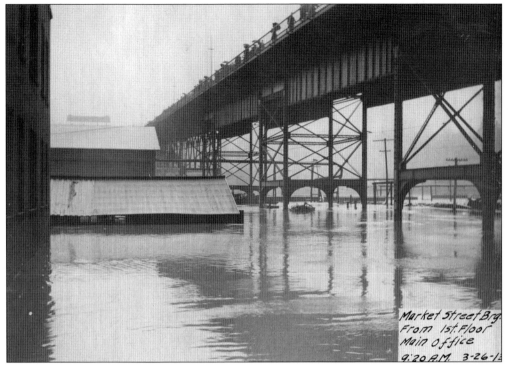

THE GREAT 1913 FLOOD. The great flood of 1913, which was experienced statewide, devastated the Mahoning Valley. In late March 1913, the Youngstown area experienced unusually heavy downpours of rain, which continued for five days. Coupled with melting snow, this was a recipe for disaster. Like many other Ohio rivers and streams, the Mahoning River overflowed its banks. When the rain and flooding stopped, the damage topped $100 million statewide, and almost 400 deaths were attributed to the flood. These two images show the damage at the Republic Iron & Steel plant in Youngstown.

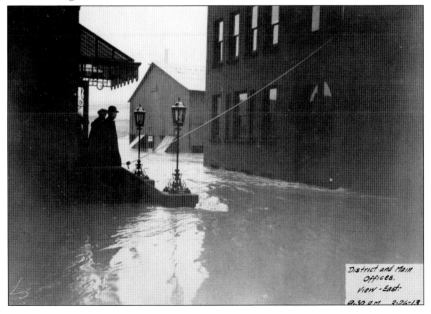

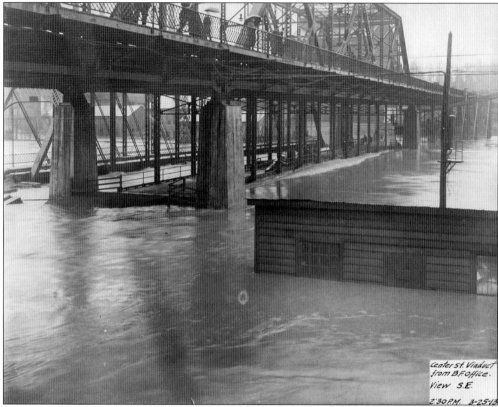

Center St. Viaduct
from B.F.Office.
View S.E.
2:30 P.M. 3-25-13

THE GREAT 1913 FLOOD. The rising waters of the Mahoning River took their toll, especially on industrial sites because of their proximity to that body of water. The estimated peak discharge from the river was 44,400 cubic feet, 16.5 feet above the flood stage. A total of four and one-fourth inches of rain fell in the torrential downpour, and the Mahoning Valley suffered enormously for days and weeks afterwards. Industry was crippled, people were without clean water and power, and major bridges were destroyed. Joseph G. Butler, in his history of Youngstown and Mahoning County, described the event as "four days of a ceaseless downpour." The community's hilly terrain actually worked in its favor as the majority of residences were above the floodplain. These images depict the flood at its height on mill property.

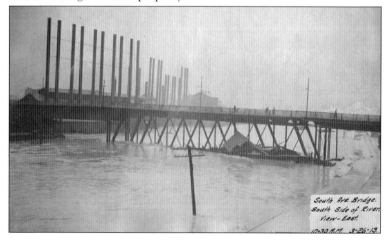

South Ave. Bridge.
South Side of River.
View - East.
10:30 A.M. 3-26-13.

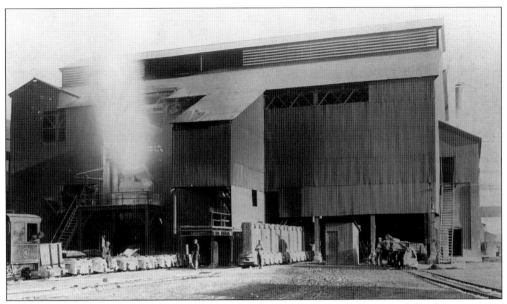

IRON SHEET & TUBE BESSEMER CONVERTER. The Youngstown Iron Sheet & Tube Company was incorporated in 1900. The founders included George D. Wick, William Wilkoff, Edward L. Ford, George L. Fordyce, and James A. Campbell. Wick was named the company's first president, and he, Campbell, and Wilkoff selected the site for the new steel mill. Upon discovering the need for more startup money, directors agreed to raise the capitalization from $600,000 to $1 million. Seen here is the Bessemer converter.

IRON SHEET & TUBE RAILROAD TRACKS. The site selection committee, after eliminating several possibilities, settled on land that was essentially a wheat field located east of Youngstown along the Mahoning River. Given its location on the river, the company felt that this site made optimal use not only of the water supply, but also of the existing railroad lines. While the Mahoning River itself was not navigable for industrial purposes, it was used to cool equipment and also for waste removal. The rail lines meant that the essential raw materials (iron ore, coal, and limestone) could be easily shipped in and the final product shipped out.

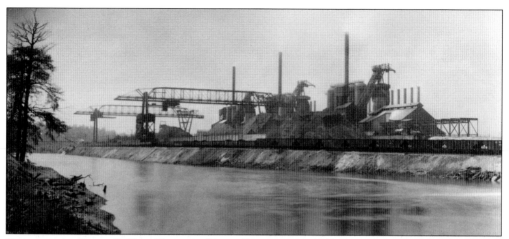

YOUNGSTOWN SHEET & TUBE COMPANY BLAST FURNACES, C. 1911. Construction of the plant began early in 1901. An engineer from Pittsburgh, S.V. Huber, worked closely with James A. Campbell on the design of the new facility. As early as 1902, its owners recognized that steel production would supersede iron manufacture, especially in pipe production. By 1905, the company removed "iron" from its name and officially became the Youngstown Sheet & Tube Company (YS&T).

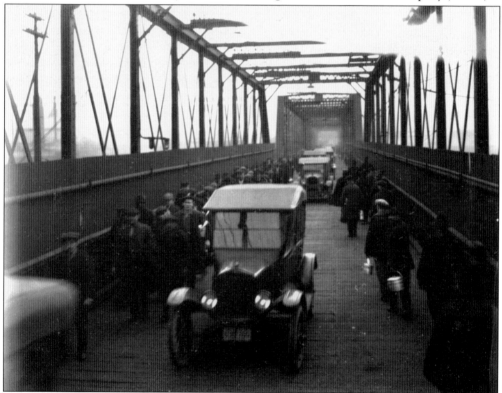

YS&T NORTH GATE. In 1904, YS&T elected James A. Campbell as president; he served in that position until 1930. The company continued to expand, opening its Bessemer facility in 1906 and its open-hearth facility in 1913. These two facilities mark the clear acknowledgment that steel product was YS&T's chief concern. This image shows the East Youngstown plant's North Gate, which was off Wilson Avenue.

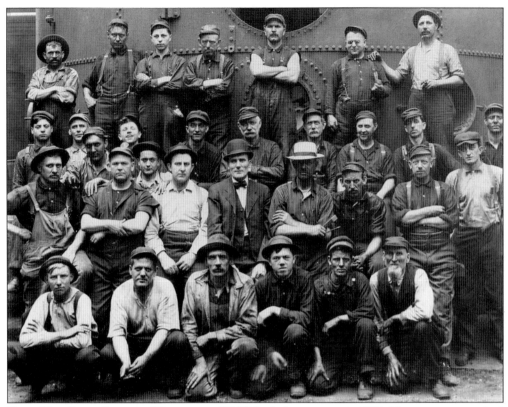

BRIER HILL STEEL COMPANY MACHINISTS. YS&T had a banner year in 1923. The company acquired the Brier Hill Steel Company on Youngstown's north side, which became the Brier Hill Works of Youngstown Sheet & Tube. YS&T also acquired Steel & Tube Company sires in Chicago and Indiana Harbor that same year. These machinists from Brier Hill Steel are pictured in 1912, the year the company was founded.

YS&T SOUTH GATE.
In 1926, the city of East Youngstown was renamed Campbell in honor of James A. Campbell. That same year, YS&T's main plant was renamed the Campbell Works. At its peak, it housed four blast furnaces, twelve open-hearth furnaces, two Bessemer converters, slab mills, a 79-inch hot strip mill, rod and wire mills, bar mills, a butt-weld pipe mill, and a seamless tube mill. The south gate, seen here, was located on Poland Avenue.

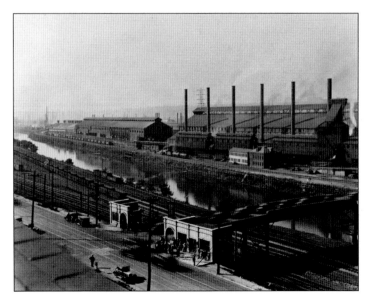

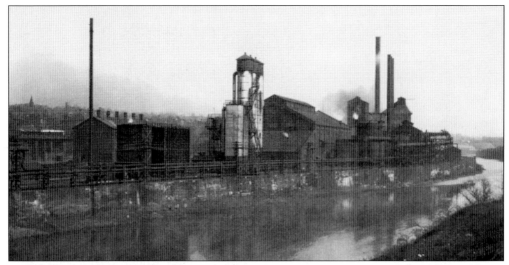

YS&T Company Brier Hill Works. YS&T's Brier Hill Works contained two blast furnaces, officially named Grace and Jeannette, 12 open hearths, plate mills, a blooming mill, a round mill and an electric tube mill. The acquisition of Brier Hill marked a major period of expansion for Youngstown Sheet & Tube. The company, at its peak, was the nation's fifth-largest steel manufacturer.

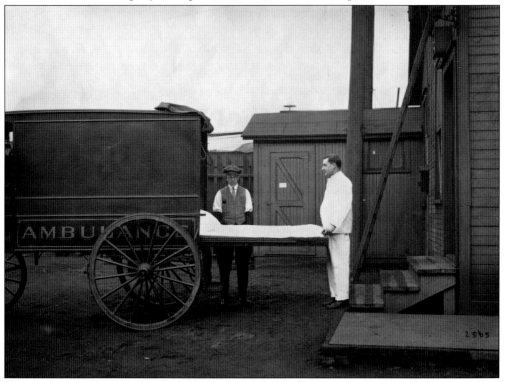

YS&T Ambulance and Stretcher. Like many large industrial complexes, YS&T maintained hospital facilities on site and had a small ambulance fleet. The company's medical facilities were tested during the Spanish Influenza epidemic of 1918, which YS&T spent about $35,000 to combat. The company gave free vaccinations to 5,072 employees and their families, among which only 35 contracted the disease; there were no fatalities.

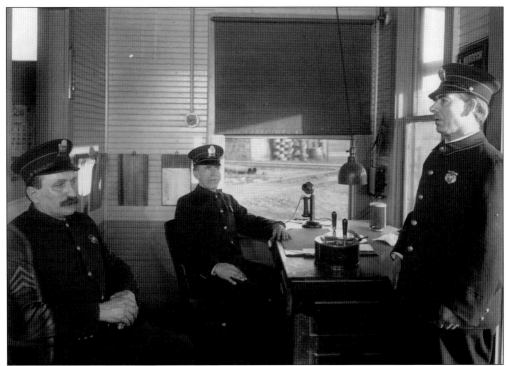

Youngstown Sheet & Tube Company Safety. YS&T's management prided itself on what it believed were its good employee relations. In 1912, a company-wide safety program—which included the inauguration of a new department exclusively designed for the promotion of safety—was instituted to reduce accidents and deaths on the job. R.J. Kaylor, the author of the company's 30-year history, claimed that YS&T was a pioneer in the field, pointing out that the first safety work was carried on through employee committees that were empowered to make recommendations to eliminate dangers from machinery. YS&T's employees formed the nucleus of the second safety council in the United States. These images depict the push toward a safer workplace. Pictured above are the company guards who protected both the company's property and its people, ensuring safety regulations were enforced. Seen below are Sheet & Tube's employee representatives to the safety committee.

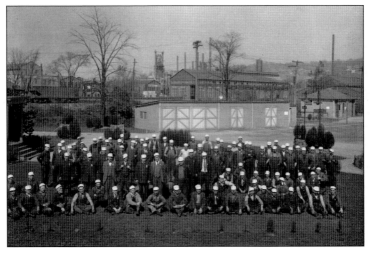

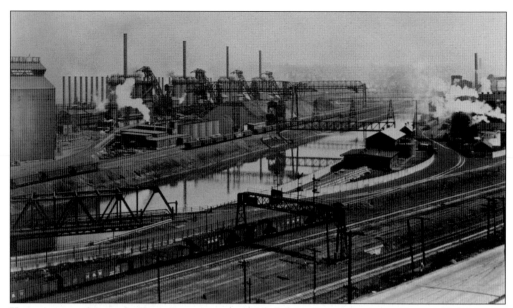

YOUNGSTOWN SHEET & TUBE COMPANY, C. 1920. Like other major corporations, Youngstown Sheet & Tube tried to integrate various operations to facilitate the production of iron and steel. Besides acquiring Brier Hill Steel, YS&T also owned numerous subsidiaries, including the Maysville (Wisconsin) Iron Company, Youngstown Steel Products Company, Continental Supply Company, Nemacolin Supply Company, Youngstown Mines Corporation, Buckeye Coal Company, Vinegar Hill Zinc Company, and Northwestern Drilling Company, to name just a few. The flagship East Youngstown plant is seen here in about 1920; all four blast furnaces, which were completed between 1907 and 1913, are visible.

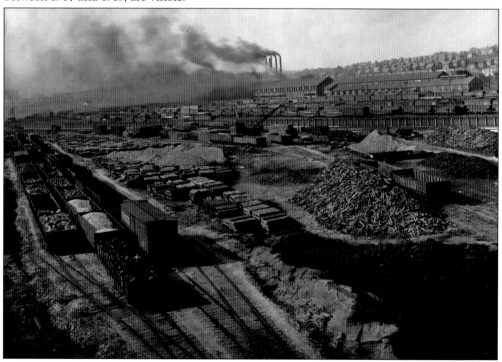

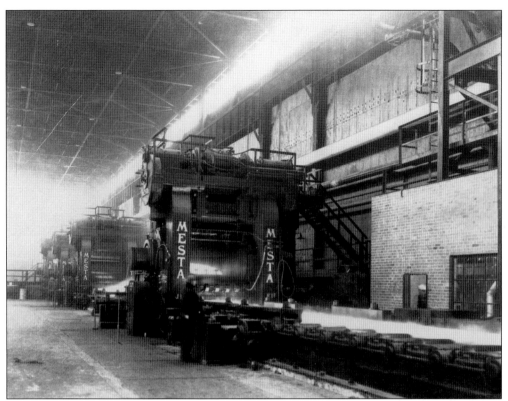

YOUNGSTOWN SHEET & TUBE COMPANY. By 1929, YS&T was the Mahoning Valley's largest employer. During the Great Depression, however, production greatly slowed. Although YS&T prospered during World War II and the postwar period, cracks began to appear in the industry. In 1969, the Lykes Corporation, a steamship company operating out of New Orleans, purchased YS&T, a move likened at the time to "a guppy swallowing a whale." On September 19, 1977, a day known locally as "Black Monday," Lykes announced the closure of the Campbell Works. It then sold the Brier Hill Works and the plants in Indiana to Jones & Laughlin (J&L) Steel, which closed Brier Hill in 1979. These two images are of finishing operations. Above is the 79-inch hot strip mill, which was constructed in 1935, and below is the seamless tube mill.

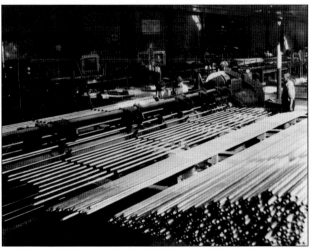

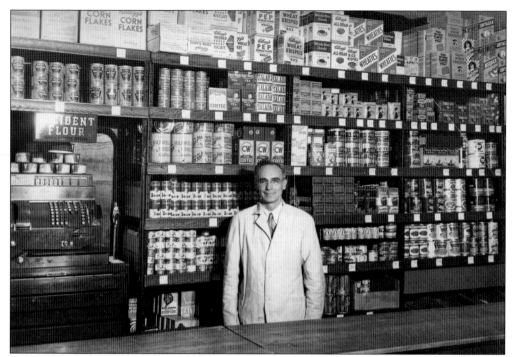

YS&T Company Store. During its heyday, Youngstown Sheet & Tube operated several company stores. Unlike those in isolated coal-mining communities, these retail establishments, which were in competition with stores not owned by the company, had to set fair prices. Sheet & Tube referred to these as "cooperative stores," indicating that they were working with their employees to give them better access to their staples.

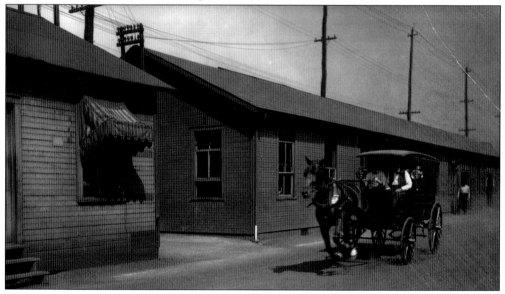

Youngstown Sheet & Tube Carriage. In the early days of its operations, Youngstown Sheet & Tube still maintained horses and carriages on the mill grounds, seen here. Although automobiles were available in the early 20th century, the company persisted in using this older form of transportation. Eventually, the horse and buggy were phased out in favor of more modern equipment.

Two

WORKERS AND WORK

Work defined Youngstown and the Mahoning Valley. The iron and steel industries brought prosperity to the region, especially by the early 20th century. The mills required thousands of workers, mostly unskilled, many of whom were immigrants from southern and eastern Europe, and later, African Americans from the South. The growing workforce and changing workplace meant that relations between labor and management were in flux. The first national federation of craft unions, the American Federation of Labor (AFL), organized in 1886. The AFL, and its longtime president, Samuel Gompers, declined to organize unskilled workers, immigrants, women, and African Americans. While the AFL preferred not to strike, it was involved in several important labor conflicts, most notably the 1893 Homestead Strike in Pennsylvania (which was instigated by an AFL union, the Amalgamated Association of Iron and Steel Workers). The Homestead Strike, however, was a major setback to organized labor, especially in the ferrous industries. Youngstown experienced labor strife as well in the early 20th century. Prior to the rise of industrial unionism in the 1930s, there were several strikes, most notably in 1916 and 1919. Following a period of relative quiet in the 1920s, the Mahoning Valley was the site of major conflict in the 1937 Little Steel Strike.

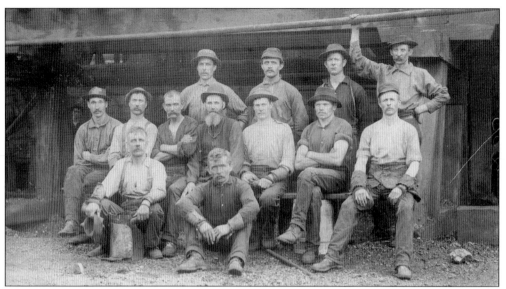

SHEAR TEAM AT BROWN, BONNELL & COMPANY. In 1854, iron makers from New Castle, Pennsylvania—William Bonnell, Joseph H. Brown, Richard Brown, and Thomas Brown—purchased the Youngstown Iron Company, organizing Brown, Bonnell & Company. Over time, the company acquired coal mines and the Falcon and Phoenix Furnaces, and it was absorbed by the Republic Iron & Steel Company in 1899. Seen here is a shear team at Brown, Bonnell & Company in 1875. Their job was to cut iron to the proper size.

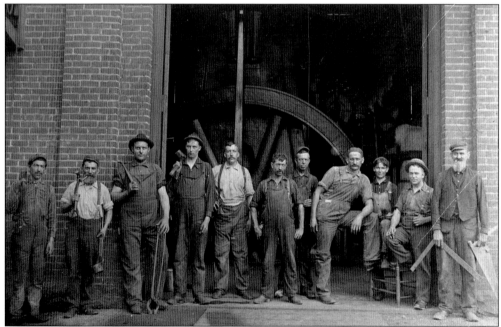

YOUNGSTOWN STEEL COMPANY WORKERS. These workers at the Youngstown Steel Company pose with their tools in the late 19th century. It was not uncommon in this period for workers to show great pride in their labor; they did not dress in their Sunday best, but in their daily work clothes. This company was formed in 1882 to produce steel casings. In 1912, the Brier Hill Steel Company purchased its property, and it remained a holding company well into the 1920s.

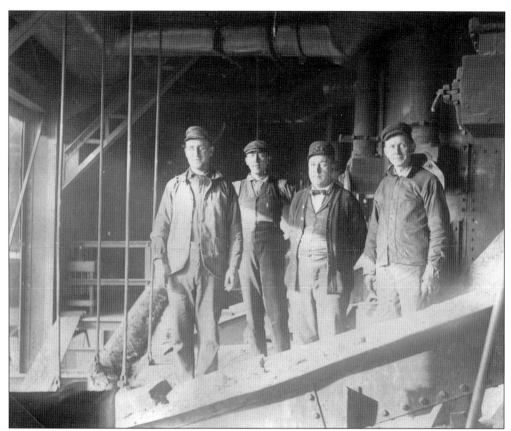

OHIO WORKS EMPLOYEES. These two photographs were taken by Frank Hall on December 9, 1900, at what became the Ohio Works of Carnegie Steel. The image above includes, from left to right, John Richardson, John Malloy, Louis Johns, Charles Beam, and an unidentified man. They were all a part of the blast furnace cupola team. The photograph below includes, from left to right, Charley Beam, Chris Fox, Billy Bowstead, and Chris Vogel. Hall noted that Beam was the cupola foreman and Vogel was his first helper. Bowstead went on to be a bricklayer at the Bessemer plant of the Republic Iron & Steel Company.

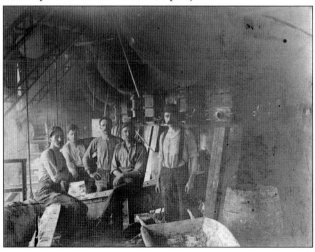

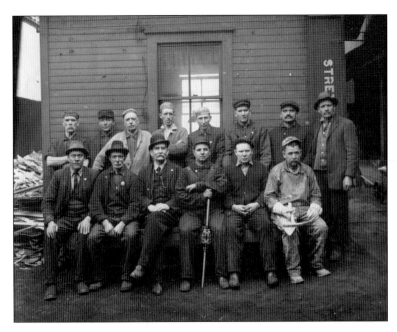

PUDDLE MILL SAFETY COMMITTEE, CARNEGIE STEEL. Puddling was a skilled trade in the iron industry that was slowly being superseded by less skilled and unskilled labor in the steel industry. The puddlers who did the actual labor are clad in their work clothes, and the formally dressed men are their supervisors. Note that several of the puddlers hold tools of their trade.

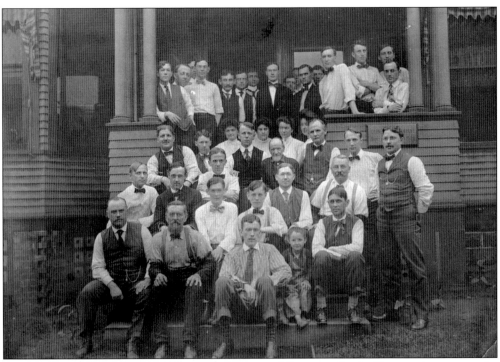

CARNEGIE STEEL MILL PERSONNEL, 1915. A group of Carnegie Steel office employees pose for the camera in 1915. Note the presence of women, who were most likely secretaries, bookkeepers, or clerks. The child seated in the front is probably not an employee of the company; the nature of work in the steel mills meant that the industry employed few children because they lacked the physical strength required.

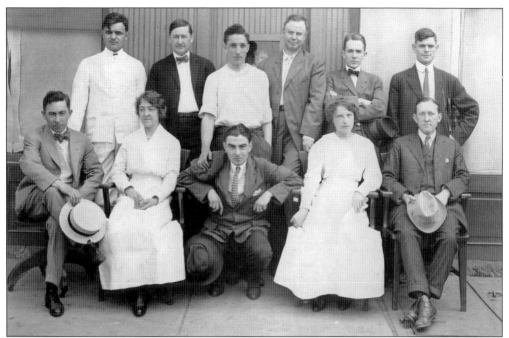

YS&T MEDICAL STAFF AND WOMEN OF SAFETY. In the early 20th century, critics besieged heavy industry, assailing them for their hazardous working conditions. Muckraking reporters like Ida Tarbell brought attention to the dangerous life on the factory floor. These writers were part of the Progressive movement that believed American society could be improved through good government and more stringent regulations. In response to reformers, companies like YS&T engaged in a program referred to as "welfare capitalism." It included provisions for safety in the workplace and also provided on-site medical care for persons injured on the job, as seen above. Note also the number of women employed by the industry. While women did not work on the factory floor in great numbers until World War II, they did fill positions in the various offices, the company kitchen, the company store, and the medical facilities. Women are also included in various company committees such as the safety committee, seen below.

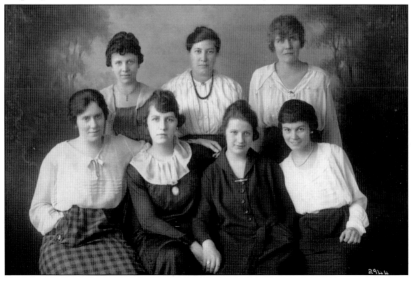

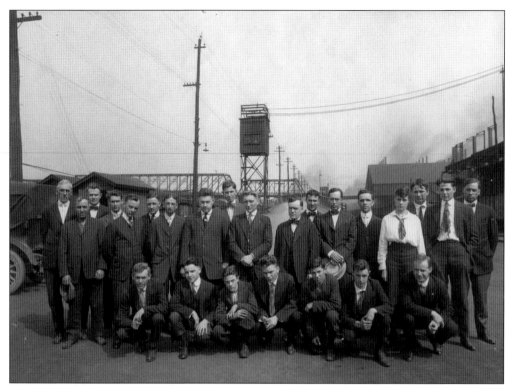

YS&T Pay Department. Not all of the jobs in steel mills involved working on the factory floor. Many office workers were also required to run these large operations. The men in both images worked in YS&T's pay office, where they ensured that all the employees received their money in a timely fashion. Both images date from about 1910.

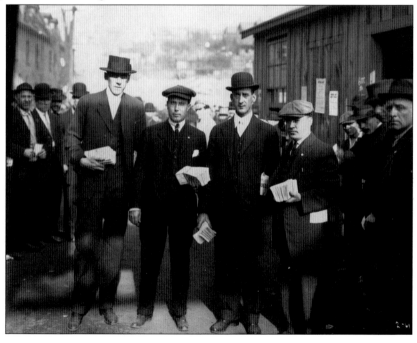

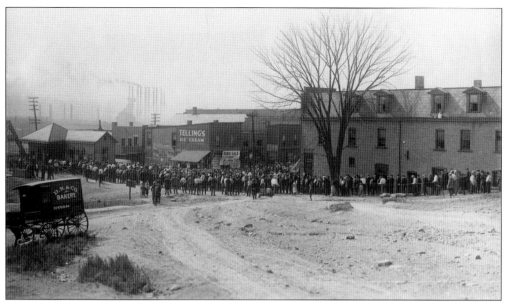

BONUS-PAY LINE, C. 1910. Youngstown Sheet & Tube, as part of its efforts to improve relations with its employees, offered a bonus pay when times were good. The line stretches from the north gate of the East Youngstown facility up the hill and into part of the business district.

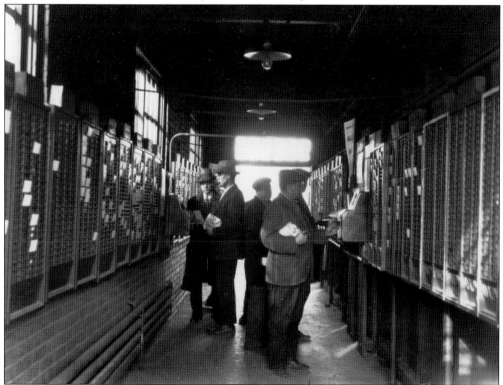

CLOCKING IN. By the time this 1920s photograph was taken at YS&T's Brier Hill Works, employees clocked in and out by machine. Mechanization made it easier to keep track of employee work hours and facilitated payment of salaries. This was particularly important as the workforce grew.

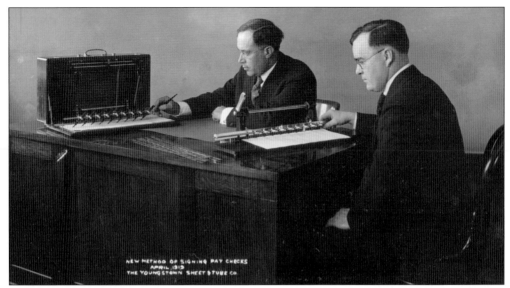

SIGNATURE MACHINE. In 1919, Youngstown Sheet & Tube introduced its signature machine, another tool to facilitate payment to employees. As more and more companies paid their employees by check rather than in cash, such modern mechanisms became indispensable to management.

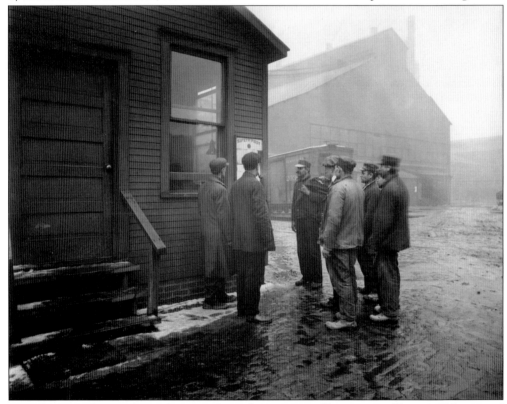

MEN READING SAFETY SIGN. As part of its safety program, Youngstown Sheet & Tube posted warnings around the plant about the dangers of the factory. The signs were often posted in various languages so the company's diverse staff could read them and make sure to heed the warnings.

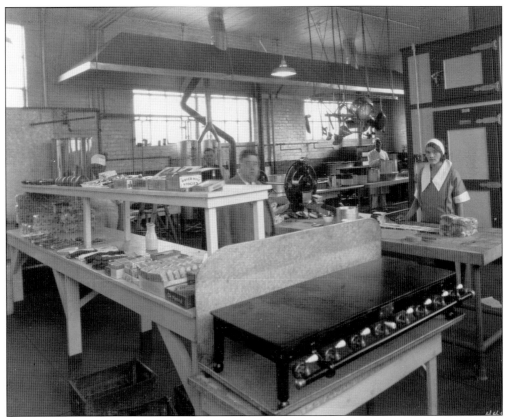

YOUNGSTOWN SHEET & TUBE KITCHEN WORKERS. By the late 1930s, Youngstown Sheet & Tube had facilities to provide food service for its employees, so workers did not always have to pack their lunches. The kitchen was another venue that employed women, although once again in a traditionally female occupation.

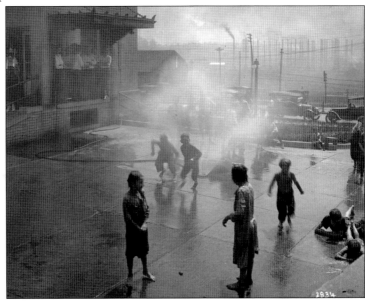

CHILDREN HAVING FUN. Several YS&T employees take a break from their jobs and enjoy observing the neighborhood kids cooling off in the summer heat. This photograph from the 1930s was taken on Walton Avenue at the company's Campbell Works office, across from the south gate entrance into the mill.

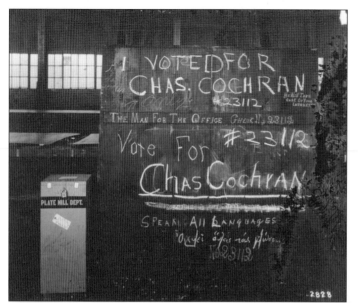

SIGN FOR CHARLES COCHRAN, 1934. In the early 1930s, the Youngstown Sheet & Tube Company inaugurated an employee representation plan, also known as a company union. These types of unions, many of which were attempts to counteract efforts at collective bargaining, were run by management. Employees could vote for their representatives, but in reality they had very little power. This sign for Charles Cochran, who ran for election, boasts that he "speaks all languages."

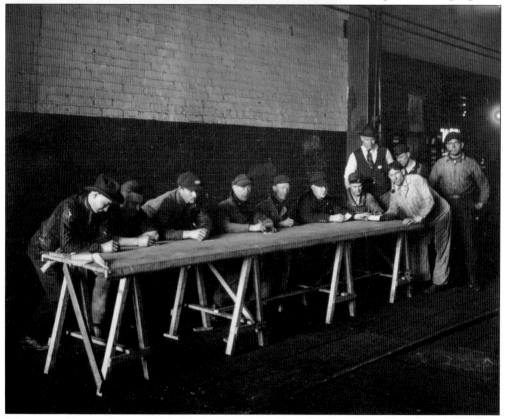

MEN WITH VOTING SLIPS, 1934. These YS&T employees are voting in the elections for their representatives to the company union. Issues that were truly important—such as salary, wages, hours, sick days, and the like—were usually not open to negotiation. Still, the company union did provide at least some voice to the workers in lieu of true collective bargaining.

COUNTING THE VOTES, 1934. With voting for representatives to the company union completed, YS&T employees tally the votes. With the passage of the Wagner Act in 1935 and the rise of industrial unions in the 1930s, many company unions could not survive the move to collective bargaining.

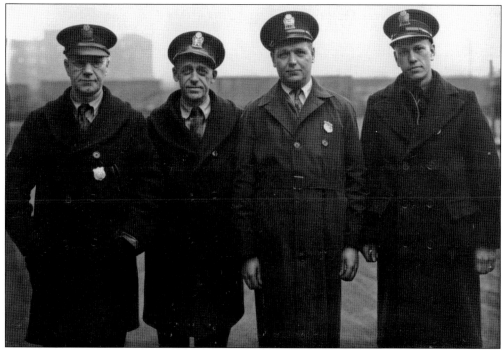

COMPANY POLICE. Like many large companies, YS&T employed police to protect both its property and its people. At the same time, the company police, along with extra security hired by the company, were also used against workers when they went on strike.

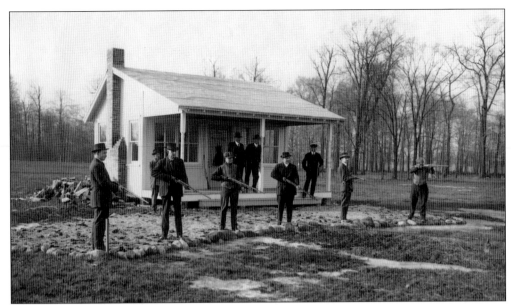

ARMS SAFETY AND UNIFORMED GUARD. At the end of 1915, workers at the Youngstown Sheet & Tube Company's plant in East Youngstown went on strike following a walkout at nearby Republic Iron & Steel. To protect itself and—more importantly—its property, the company brought in more security, many of whom were off-duty policemen from the neighboring communities. The image above shows security being trained. Below is a group photograph of the uniformed guard in front of the YS&T office building on the corner of Poland Avenue and Walton Street, just across from the south gate to the plant. Clearly, the company was expecting trouble during the walkout.

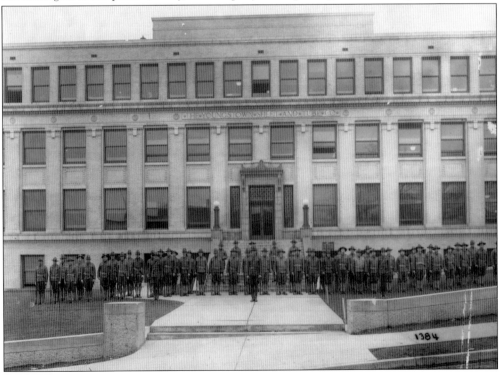

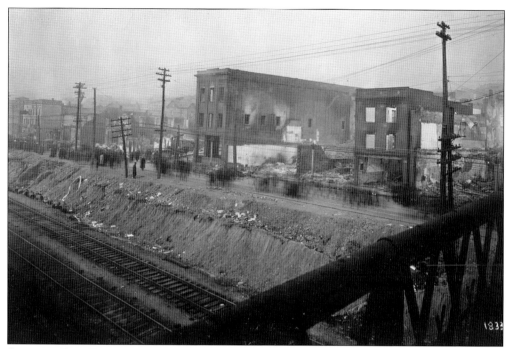

STRIKE IN EAST YOUNGSTOWN, 1916. In December 1915, workers at Republic Steel in Youngstown walked off their jobs. Soon after, in a sympathy strike, YS&T steelworkers also walked. The main issues were pay, hours, and working conditions. Until 1923, the steel industry operated on two 12-hour shifts (or turns). Whenever a worker had to go from one turn to the other, he was forced to work for 24 hours straight. The men called this the "long turn." One steelworker commented that a man could die on the long turn and he would not even know it. These man-killing hours were a major impetus for the strike.

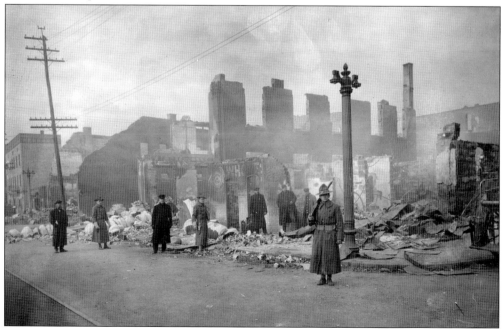

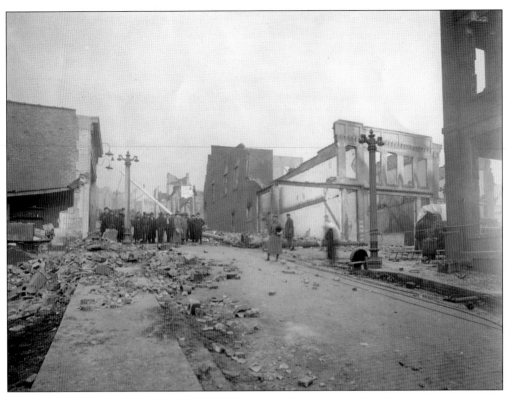

AFTER THE RIOT, 1916. On January 7, 1916, a crowd of steelworkers massed outside the north gate to the YS&T plant. One of the off-duty policemen hired by the company fired into the crowd, which touched off a riot. In the process, the rioters burned down half of the business district of East Youngstown. The next day, the National Guard was called in to restore order. At this point, the strike was essentially over, and most of the men went back to work. Joseph G. Butler, in his 1922 book *History of Youngstown and the Mahoning Valley*, reflected the prejudice against immigrants at the time when he commented that the riot occurred because steelworkers from eastern Europe were imbibing in celebration of Christmas and that the chaos was caused by alcohol.

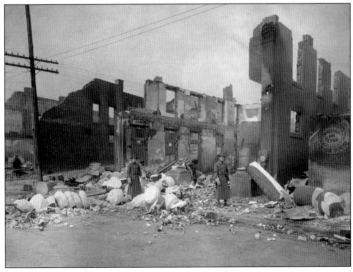

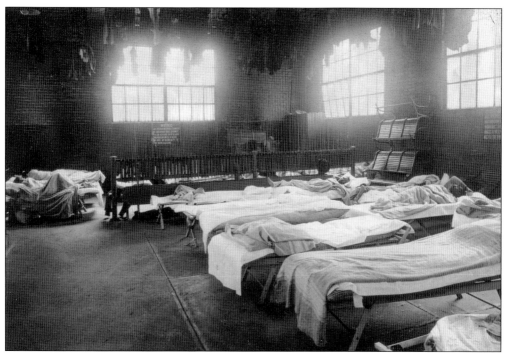

THE 1919 STEEL STRIKE. Following the end of World War I, the steel magnates made a concerted effort to block attempts at unionization. In Pittsburgh, steel company owners harassed union members, who eventually pushed back. The American Federation of Labor was reluctant to strike, but disgruntled workers threatened to leave the movement if a strike was not called. The strike began on September 22, 1919, and about half of the US steel industry (including plants in the Youngstown District) shut down. The companies used many tactics to break the strike, including hiring between 30,000 and 40,000 African Americans and Mexicans as strikebreakers. The Great Steel Strike of 1919 collapsed and was over on January 8, 1920. One of its results was that there was little union activity in the industry for 15 years. The two images seen here show rooms on company property that housed security at YS&T for the duration of the strike.

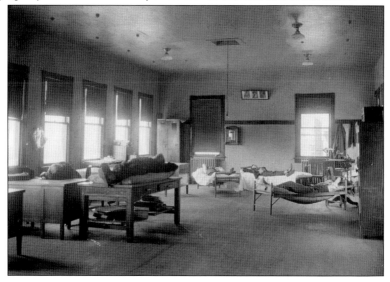

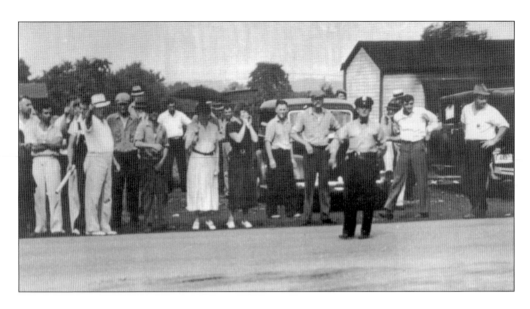

PICKETERS AND SYMPATHY MARCHERS, 1937. With the coming of the New Deal and the federal government's more tolerant attitude toward organized labor, a new push was made to organize all of the workers in heavy industry—especially those involved in the manufacture of automobiles, rubber, and steel. The Congress of Industrial Organizations (CIO) formed in 1935 under the leadership of United Mine Workers president John L. Lewis. The CIO established the Steelworkers Organizing Committee (SWOC), which was headed by Philip Murray of the United Mine Workers. In March 1937, US Steel ("Big Steel") president Myron C. Taylor saw the handwriting on the wall and signed a collective bargaining agreement with SWOC. The so-called Little Steel Companies, which included the Youngstown Sheet & Tube Company and Republic Steel in the Mahoning Valley, chose to defy the attempt at unionization. On May 26, 1937, some 75,000 steelworkers walked off their jobs.

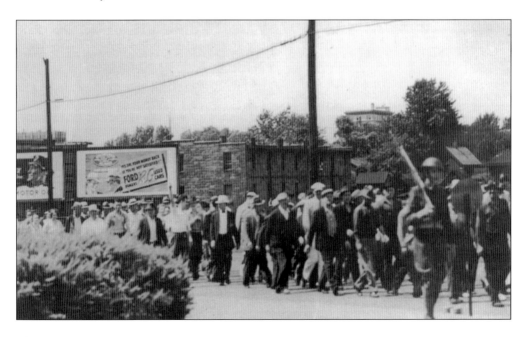

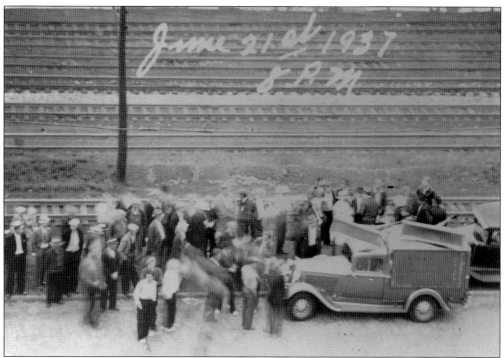

MEN RETURNING TO WORK. The so-called Women's Picket began peacefully on June 19, 1937, until Youngstown police captain Charley Richmond decided enough was enough and demanded the women be removed from the picket line at Stop 5, near the Republic Youngstown plant. Using tear gas, police scattered the picketers. The demonstrators were reinforced by SWOC members, and violence quickly escalated when someone guarding the plant fired into the crowd. Throughout the night, the police and deputies fired continual volleys of tear gas and ammunition at the crowd gathered on Poland Avenue. Following a rally of 5,000 steelworkers and supporters, Frank Purnell and Tom Girdler—presidents of YS&T and Republic respectively—refused to meet with federal mediators and announced they were reopening the mills. By the end of July, the strike was essentially over, and the Little Steel companies did not recognize the union until 1942. These images depict the men returning to work at Youngstown Sheet & Tube.

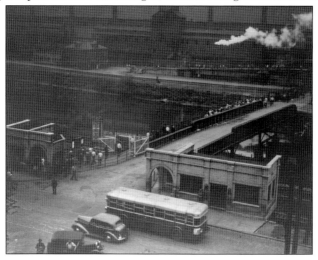

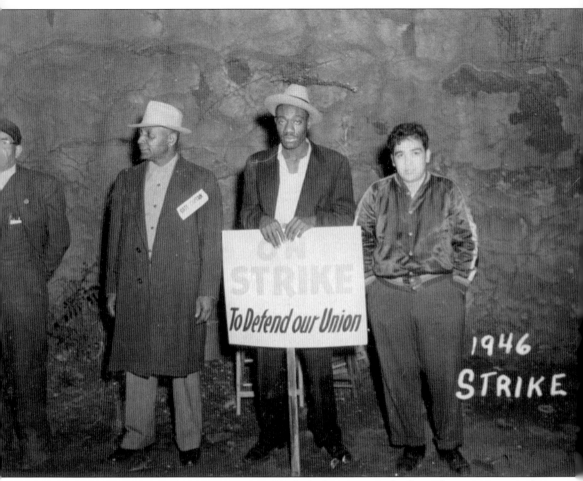

AFRICAN AMERICANS IN ORGANIZED LABOR. With the beginnings of industrial unionization in the mid-1930s, all races and ethnic groups were included as potential members. The older American Federation of Labor craft unions often discriminated on the basis of race, ethnicity, and gender. However, even though any rank-and-file person could join the union, they were not necessarily treated equally. African American union members had to fight for their rights within organized labor as well. Some union locals were less discriminatory than others, but at least the union did provide a way for African Americans to improve their work environment. Legislation like the Civil Rights Act of 1964 also helped in making the workplace more equitable. Despite this, it took until 1974 for the Consent Decree to force several steel firms and the United Steelworkers of America to end racial and gender discrimination and award back pay to victims of discrimination within the industry. These men picket during the 1946 strike.

Three

PEOPLING YOUNGSTOWN

Youngstown and the Mahoning Valley are a microcosm of the United States. The area is diverse, composed of many different ethnic, racial, and religious groups. The early settlers were Connecticut Yankees following in the wake of founder John Young. The period just before the Civil War saw an influx of Welsh, German, and Irish immigrants—drawn variously by the canal, by the railroads, by coal mining, or by the iron industry. Many of the city's movers and shakers rose from the ranks of these settlers. The early 20th century saw a great increase of immigrants from southern and eastern Europe as well as African Americans from the South. Postwar Youngstown attracted many from Puerto Rico who sought good jobs in the steel mills. The area was also a magnet for people from the Middle East and Asia as well. The diversity of the region is the hallmark of the Mahoning Valley.

James A. Campbell. James A. Campbell had a long history in local business and industry. He was born on September 11, 1854 in Ohltown, Ohio, just outside of Youngstown. He worked in various businesses, eventually founding the Youngstown Ice Company. He then turned toward the burgeoning iron industry, becoming superintendent of the Mahoning Valley Iron Company in 1895. He resigned five years later in 1900, when Republic Iron & Steel absorbed the Mahoning Valley Iron Company. Campbell soon became involved with other investors in forming the Youngstown Iron Sheet & Tube Company. In honor of his contributions to the YS&T's company headquarters, East Youngstown was renamed Campbell in 1926. Within four years, he was its president, a post he held until 1930. Above, James Campbell is seen at home on Logan Avenue with his wife, Etta. At left, Campbell is pictured with one of his grandchildren.

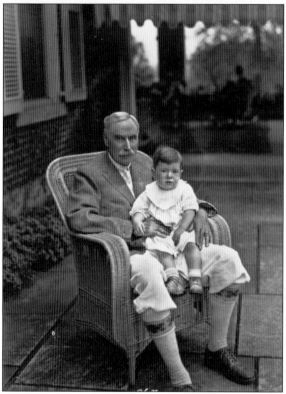

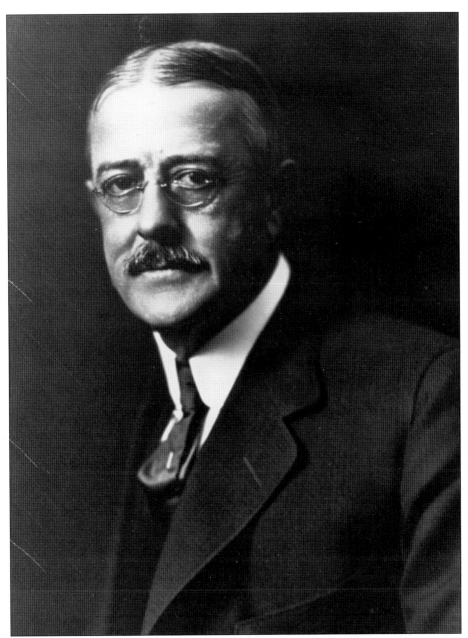

GEORGE DENNICK WICK. One of the founders of the Youngstown Sheet & Tube Company, George Dennick Wick was born on February 14, 1854, in Youngstown. The Wicks, early settlers of the area, were community leaders. Their earliest ventures were in real estate, but they later entered other areas like banking as well as the burgeoning iron and steel industries. Wick was a founder of the Youngstown Iron Sheet & Tube Company and served as its first president. In 1904, Wick resigned as president because of ill health. In 1912, he, his wife Mary Hitchcock Wick, their daughter Natalie, cousin Caroline Bonnell, and Caroline's aunt Elizabeth Bonnell were returning home from a European tour. Unfortunately, they were sailing on the *Titanic*'s ill-fated maiden voyage, April 10–14, 1912. George Wick went down with the ship, although the rest of their group survived.

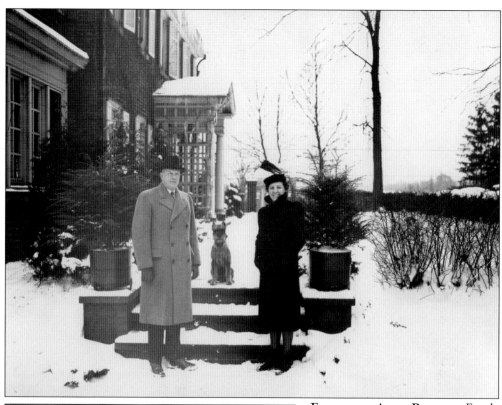

FRANK AND ANNA PURNELL. Frank Purnell was James A. Campbell's handpicked successor as president of the Youngstown Sheet & Tube Company in 1930. He served in that capacity during the 1937 Little Steel Strike and was a staunch opponent of unionization. Purnell also led the company through World War II as it helped the Allies win the war. Purnell and his wife, Anna, are seen here in front of their home on fashionable Tod Lane on Youngstown's north side.

WALTER BARTZ AT WORK. The longtime photographer for the Youngstown Sheet & Tube Company was Walter Bartz. Born in 1884 in Ohio, Bartz started as a clerk at YS&T in the teens and became staff photographer in 1920. His images, many of which are in this volume, recorded much of Youngstown Sheet & Tube's history until the 1950s.

THE WICK AND FORD FAMILIES. Members of two prominent Youngstown families, the Wicks and the Fords, are seen in these two images. Above, several members of both families are seen in front of the beautiful Shingle-style home at 504 Wick Avenue. The photograph below shows Helen Ford Wick as a baby in her carriage. Note the Wick Avenue streetscape that can be seen in the distance. It was structures like these, inhabited by Youngstown's elite, that gave Wick Avenue its nickname of "Millionaires Row." These people were the city's movers and shakers for many years. To consolidate their position, they often intermarried, forming not only family ties but corporate ones as well. (Both, courtesy of John Kai Lassen.)

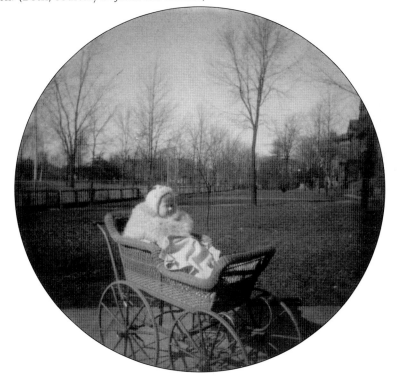

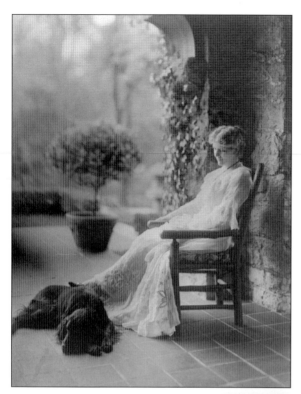

OLIVE ARMS. Olive Freeman Arms, pictured here, was the daughter of Hannah Wick and Charles Dayton Arms. She married a distant cousin, Wilford Arms, in 1899. Olive had grown up on Wick Avenue, and after she and Wilford married, they built their own house next to her parents'. Upon her death in 1960, she donated her house for the new home of the Mahoning Valley Historical Society. The structure is still operated by MVHS as a museum. (Courtesy of the Mahoning Valley Historical Society, Youngstown, Ohio.)

HOWARD JONES. The first president of Youngstown College, Howard Jones, came to the fledgling school in 1931. He served in that capacity until his retirement in 1966. The student newspaper, the *Jambar* described him as an "executive type, steady on the trigger, but a twinkle in his eye and a ready wit." Jones is seen here around 1940 on the front steps of what is now known as Jones Hall. (Courtesy of Youngstown State University Archives.)

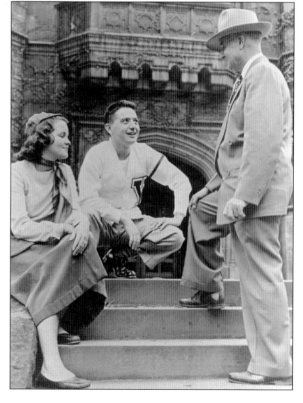

YS&T Employment Notice and Sign. Youngstown's steel industry, which required many unskilled workers, proved to be a magnet for immigrants from southern and eastern Europe. Many Americans were not happy with the arrival of these newcomers, a number of whom did not speak English and were predominately Catholic or Jewish. While some clamored for immigration restriction, big business was opposed, relying on the cheap labor immigrants provided. Companies like Youngstown Sheet & Tube realized that in order to communicate with their multinational workforce, they would have to provide necessary information in several languages. The employment notice, pictured right, and warning sign, seen below, are examples of ways the steel companies tried to deal with the newcomers. (Both, author's collection.)

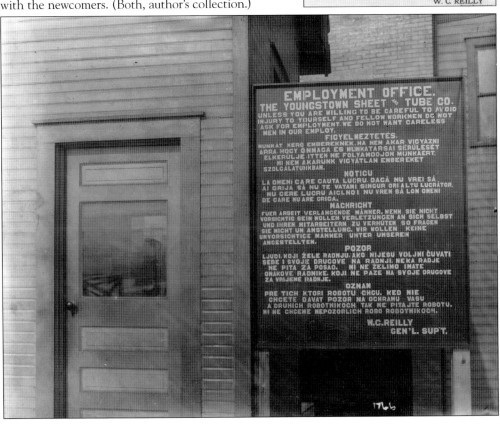

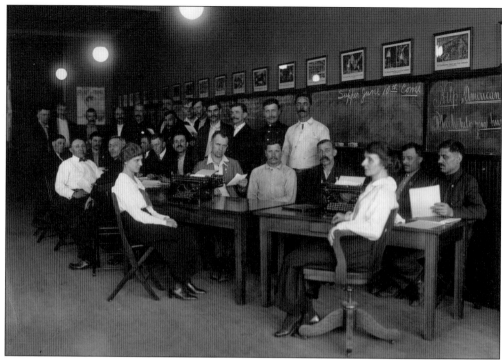

AMERICANIZATION CLASS AND NIGHT SCHOOL. The arrival of so many immigrants to the United States in the early 20th century raised many issues among those who were already here. In many cases, the newcomers were not welcome, and some citizens clamored for immigration restriction. Many large corporations, however, needed these people, who usually worked for less pay and in dangerous jobs that many Americans would not do. Some people involved in the Progressive movement sought ways to integrate the immigrants into American society. As part of its welfare-capitalism program, Youngstown Sheet & Tube, like many other companies, instituted programs to help immigrants learn English and eventually become American citizens. A YS&T Americanization class, seen above, and free night school for learning English, pictured below, are seen here. These programs were operated in conjunction with the local YWCA.

AN IMMIGRANT'S STORY. Many immigrant groups came to Youngstown in the early 20th century. While the details of their stories may differ, their experiences have much in common. Rather than an attempt to delineate each and every ethnic group who came here, this is the history of one family's journey to the United States and Youngstown, a story that is emblematic of the immigrant experience. Seen here is the passport of Alfonso Porfirio, who left his home in Trivento, Italy, in 1903 to seek work in the New World. He entered the United States at Ellis Island. Also shown is the inspection card from Ellis Island ensuring that he was healthy. It was not uncommon for the male head of household to immigrate by himself and then send for the family once he found work. Alfonso's wife, Clorinda Scarano, and his only child, Venturina, followed him two years later.

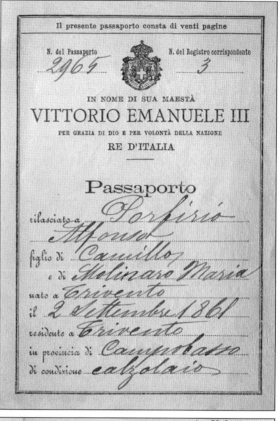

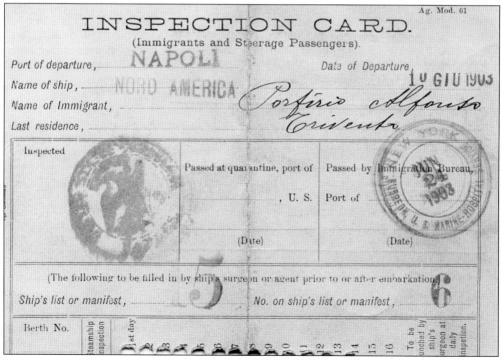

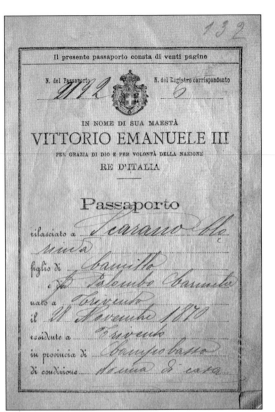

PASSPORT. Venturina Porfirio DeSantis Speroni was born in Trivento, Compbasso, in the Abruzzi region of Italy on May 9, 1898. Two years after her father emigrated, seven-year-old Venturina and her mother followed him to Youngstown, Ohio, sailing on the *Prinzess Irene* out of Naples. Like so many European immigrants, all three Porfirios entered the United States through the Ellis Island immigration station. At the time they left Italy, Venturina was a minor and did not have her own passport. Seen here are two pages of her mother's passport, which listed her as well. Note also that, in Italian, the wife is listed by her birth name, not her married name. (Both, author's collection.)

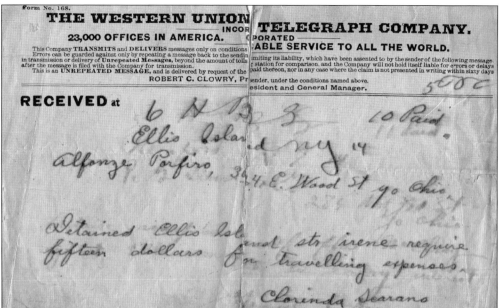

THE WESTERN UNION TELEGRAPH COMPANY.

Form No. 168.

23,000 OFFICES IN AMERICA.

INCORPORATED

CABLE SERVICE TO ALL THE WORLD.

This Company TRANSMITS and DELIVERS messages only on conditions limiting its liability, which have been assented to by the sender of the following message. Errors can be guarded against only by repeating a message back to the sending station for comparison, and the Company will not hold itself liable for errors or delays in transmission or delivery of Unrepeated Messages, beyond the amount of tolls paid thereon, nor in any case where the claim is not presented in writing within sixty days after the message is filed with the Company for transmission.

This is an UNREPEATED MESSAGE, and is delivered by request of the sender, under the conditions named above.

ROBERT C. CLOWRY, President and General Manager.

RECEIVED at

6 H B 3 10 Paid

Ellis Island ny 14

Alfonze Porfiro, 344 E. Wood St yo Ohio

Detained Ellis Isl and str irene require
fifteen dollars for travelling expenses.

Clorinda Searano

TELEGRAM AND FAMILY PHOTOGRAPH. Once in Youngstown, the Porfirios first rented rooms on East Wood Street, at the outer edge of the Smoky Hollow neighborhood. Alfonso got a job working at the Trussed Concrete Company, later known as Truscon Steel, which became a division of Republic Steel in 1935. The family soon moved into their own home in Smoky Hollow at 254 Emerald Street. Venturina would live in this house until her death in 1986. The new family home was a typical Youngstown–working-class house: one room wide and two rooms deep, with two bedrooms upstairs. Many of their neighbors were also recent immigrants from Italy, Hungary, and other eastern and southern European nations. The image above is a telegram Clorinda sent to Alfonso requesting train fare to Youngstown. In the photograph at right, the Porfirios pose in their finest clothing. (Both, author's collection.)

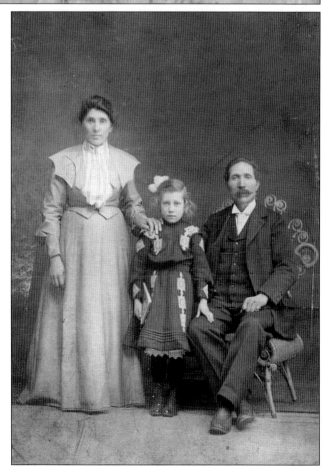

REPORT OF *Venturina Porfirio*

	Sept.	Oct.	Nov.	Dec.	Jan.	Feb.	March	April	May	June
Conduct	98	85	83	86	94	25	85	84	72	83
Reading		23	73	76	77	78	80	81	82	83
Spelling			99	97	97	98	99	97	93 99	85
Penmanship		90								94
English			82	80	83	91	81	83	82 82	88
Arithmetic		83	77	82	90	65	78	78	85	80
Geography			91	89	81	82	85	86	82	72
History										
Physiology			85	85	86	90 92	94	94	96	98
Music			86			98				
Drawing					88			88		
Bookkeeping										
German										
Days Absent									1	
Times Tardy										
Application		82 81	90	92 96	98	86	57	96	94	
Points Gained										
Points Lost										

PARENT'S SIGNATURE

September — *Alfonso Porfirio*
October — *Alfonso Porfirio*
November — *Alfonso Porfirio*
December — *Alfonso Porfirio*
January — *Alfonso Porfirio*
February — *Alfonso Porfirio*
March — *Alfonso Porfirio*
April — *Alfonso Porfirio*
May —
June —

Teacher *Miss Durlin*

Certificate of Promotion

The Bearer, *Venturina Porfirio*, is hereby promoted to the ____ 1st ____ Division of the ____ of ____ year.

N. H CHANEY, Supt.

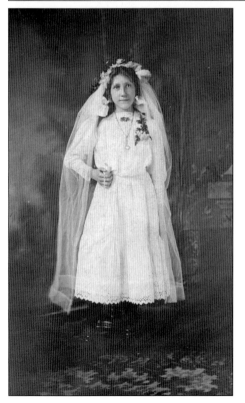

REPORT CARD AND FIRST COMMUNION.

Upon arrival in Youngstown, seven-year-old Venturina was enrolled in the Wood Street School, located on Walnut and East Wood Streets, just south of Smoky Hollow. She was a good student, as confirmed by her report card above. Venturina completed all eight grades at the school, which was the norm for most children. Few went on to high school in the early 20th century. However, once she completed her schooling, she had to help out at home. Her family shared their home with 10 boarders, a living arrangement that was very common among working-class households. Most of the boarders were either friends of friends or relatives, often from the same hometown. Venturina recalled that she and her parents slept in the front room, while the 10 boarders occupied the two upstairs bedrooms. The image at left is Venturina's First Communion photograph. (Both, author's collection.)

VENTURINA DESANTIS AND SPERONI CITIZENSHIP PAPERS. In 1920, Venturina married John DeSantis, who was also an immigrant from Italy. John worked as a shipper at a furniture store in downtown Youngstown. The couple continued to live in the house on Emerald Street, especially since Alfonso died in 1925, leaving Clorinda a widow. Venturina and John never had children. Venturina is pictured at right as a young teen. John died in 1939, and Venturina remarried in the 1940s to another Italian immigrant, Chester (anglicized from Ceasare) Speroni. Chester arrived in the United States in 1923, just one year prior to the passage of the National Origins Act, which severely limited immigration from southern and eastern Europe. He worked as a shipper at a wholesale wine company. (Both, author's collection.)

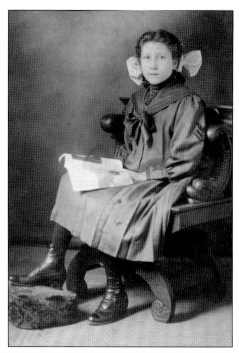

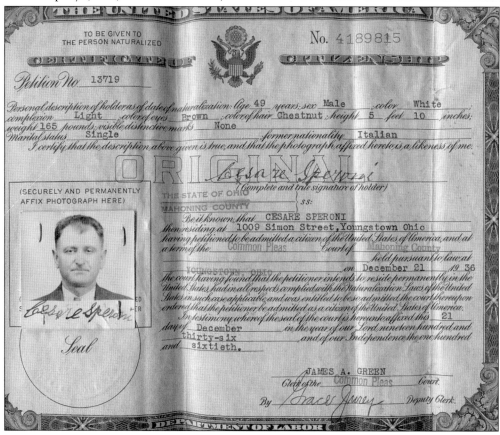

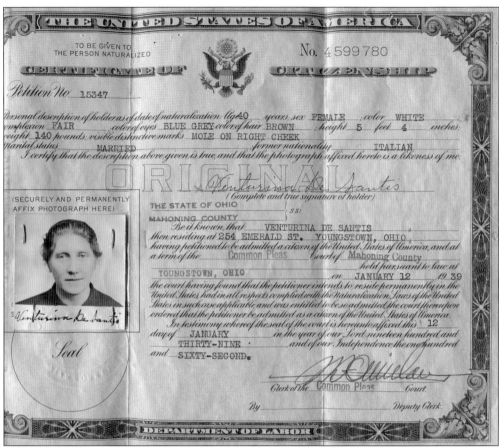

CITIZENSHIP PAPERS AND ITALIAN VISIT. In 1939, Venturina became a United States citizen. She may have been motivated to seek citizenship because of the passage of the Social Security Act in 1935, which would allow her access to her husband's pension as she herself never worked outside the home. Venturina's second marriage to Chester Speroni was short-lived as he passed away in 1952. Venturina never remarried, but lived with the family of her adopted niece in the house on Emerald Street. She finally returned to Italy in the late 1950s to visit her old homeland, which she had not seen in over 50 years. She passed away in March 1986. (Both, author's collection.)

BRIER HILL STEEL EMPLOYEES. In the early 20th century, a Brier Hill Steel Company photographer captured this image of employees and their families in front of commercial buildings in Brier Hill. Located on the city's north side, Brier Hill was a magnet for immigrants, as it was conveniently within walking distance of the Brier Hill Steel Company.

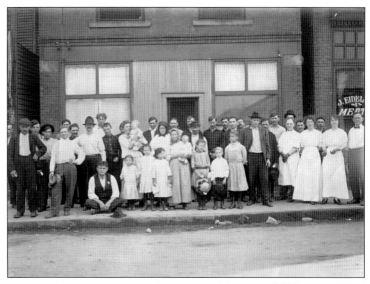

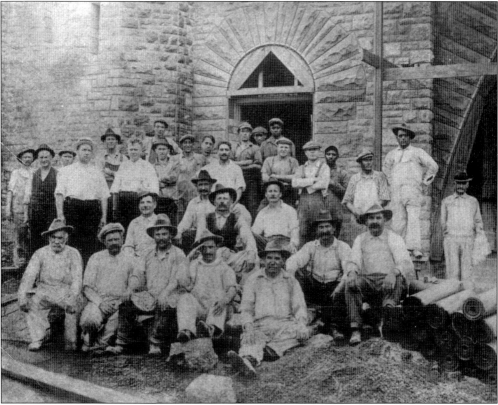

STONEMASONS. The growth of Youngstown in the early 20th century meant new construction. Not only did the city require more housing, it also needed public buildings, commercial structures, churches, schools, and modern hospitals. City Hospital, later Southside Hospital, was one such new facility. These stonemasons, many of whom were immigrants, came to Youngstown to find new opportunities. When construction slowed, they could find work lining the area's many furnaces with refractory brick.

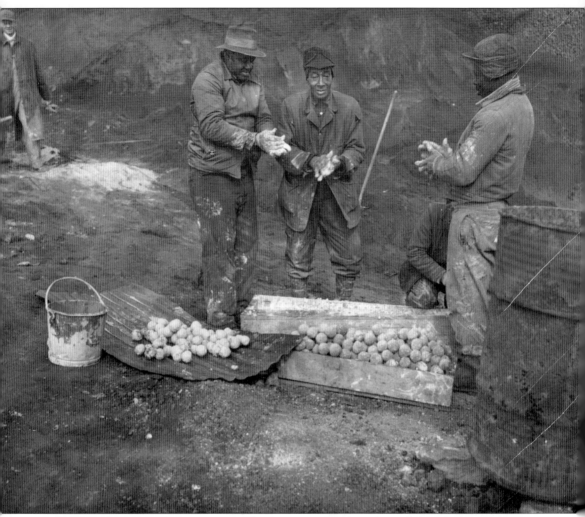

AFRICAN AMERICAN STEELWORKERS. The American South in the early 20th century was proving to be more and more inhospitable to the African Americans who lived there. Many African Americans worked as sharecroppers or tenant farmers. Even those who worked in Southern coal mines or factories often found themselves re-enslaved, if not in name, in actuality. With the growing need for unskilled labor in the North, many African Americans opted to seek out jobs in industry. In the Mahoning Valley, the African American population started to expand during the 1919 steel strike, when they were brought in as strikebreakers. Following the strike, many stayed on the job, preferring work in the steel mill to life in the segregated South. While life in the steel towns was not easy and they still faced discrimination, at least there was hope for a better life for their children. The men in this image worked at US Steel's McDonald Works in 1950.

WALTER BLACK. Walter Black was born in Tennessee in 1895. He migrated to Hubbard, Ohio (northeast of Youngstown), in 1915 to take a job at the Hubbard Blast Furnace, which was acquired by the Youngstown Sheet & Tube Company in 1916. Black, seen here in 1920, started out as part of the labor gang and then worked his way up to become one of the first African American foremen at Youngstown Sheet & Tube.

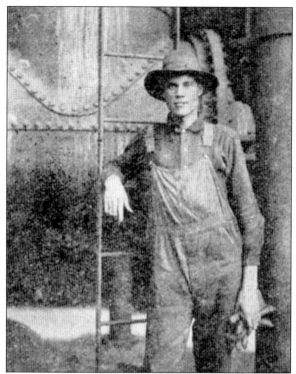

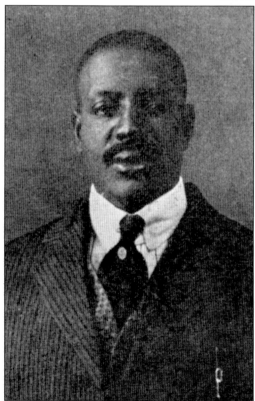

DANIEL HOLLIS. A native of Alabama, Daniel Hollis was born about 1889. He was a machinist and even taught at Booker T. Washington's Tuskegee Institute. By 1920, Hollis and his wife, Mamie, were living in Youngstown, where he worked as a blacksmith and millwright at Youngstown Sheet & Tube. He later worked as a machinist at a YS&T subsidiary, Youngstown Engineering & Foundry.

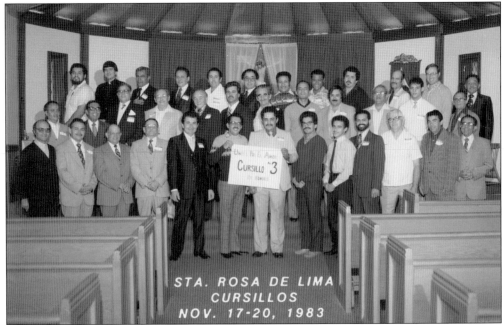

STA. ROSA DE LIMA
CURSILLOS
NOV. 17-20, 1983

PUERTO RICANS IN YOUNGSTOWN. The 1950s saw a great influx of Puerto Rican migration to the Mahoning Valley during the post–World War II boom. Like the European immigrants, many were men arriving without their families until they established themselves. Many settled on the city's east side, which still maintains a sizable Latino community. The newcomers created their own institutions, including churches, where services were—and still are—held in Spanish. In the Catholic Church, Latino faithful established Cursillos de Christiandad, which offers retreats with the goal of helping candidates understand the fundamentals of Christianity. The movement is designed to deepen the spiritual life and bring Christian involvement in daily activities. Above, this Cursillo was held at Santa Rosa de Lima Roman Catholic Church in 1986. Below, men and women of Des Colores of Santa Rosa pose for a group photograph in the 1980s.

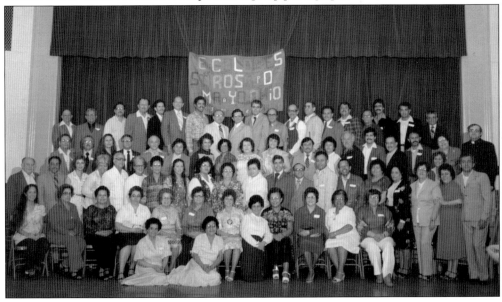

Four

OUR COMMUNITY

From humble origins as a small village on the banks of the Mahoning River in 1796, Youngstown grew into a modern city in a little over 100 years. Iron and steel brought wealth and people to the city, and those who built Youngstown through the 19th century provided a foundation for the dramatic growth in the first four decades of the 20th. The downtown changed dramatically from small buildings, no more than three or four stories tall, to grand, steel-framed skyscrapers and a bustling commercial community. Cultural and educational institutions also flourished in the city, including its first public high school during the Civil War, an impressive public library system, a world-class art museum, and an institution of higher learning that provided opportunities for betterment. The neighborhoods grew up around the mills to provide a workforce, while community leaders built grand mansions on Youngstown's version of Millionaire's Row. All of this was underpinned by the prosperity created by steel.

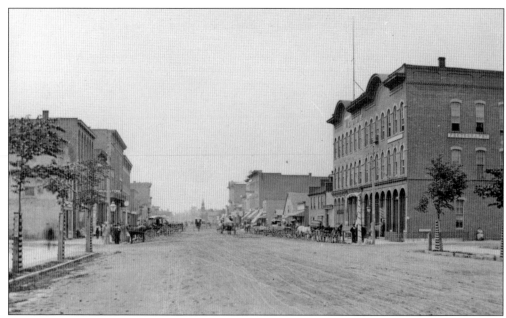

DOWNTOWN IN THE LATE 19TH CENTURY. West Federal Street at Central Square in the 1870s shows a small downtown that gives Youngstown the look more of a village than of a city. The view above looks west down West Federal Street; below is the northwest corner of Central Square, also known as the Diamond. (Both, courtesy of the Mahoning Valley Historical Society, Youngstown, Ohio.)

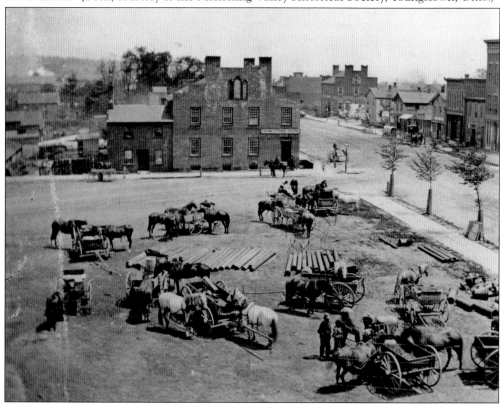

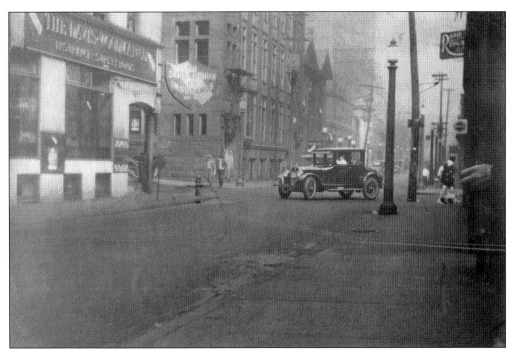

DOWNTOWN YOUNGSTOWN IN THE 1920s. By the 1920s, Youngstown had assumed a much more modern appearance, as these two images indicate. The photograph above was taken at the corner of Boardman and Phelps Streets. The one at right is on Wick Avenue, just south of the intersection with Commerce Street. Note the skyscraper in the background; that is the Dollar Bank Building, which was constructed in 1907. It was designed by one of Youngstown's most prolific architects, Charles H. Owsley. By the time this photograph was taken, Youngstown had six skyscrapers, including the Wick Building, which was designed by one of America's leading architects, Daniel H. Burnham.

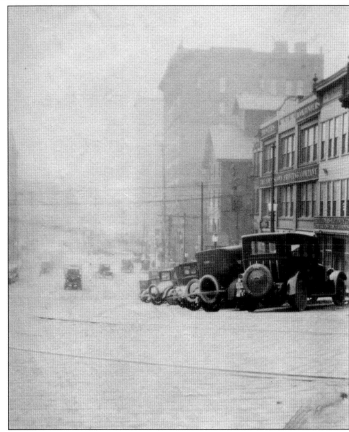

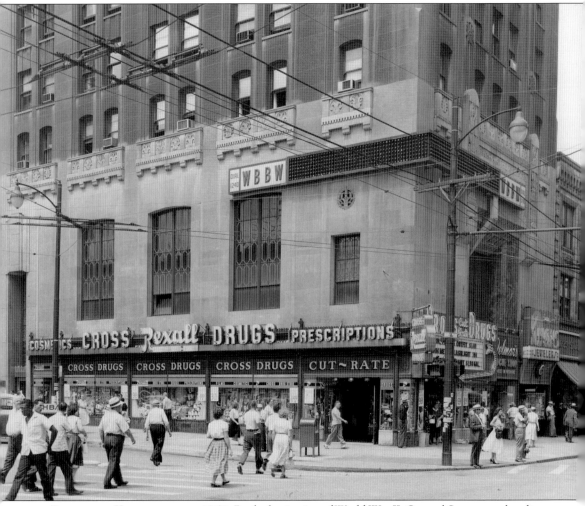

DOWNTOWN YOUNGSTOWN, C. 1950. By the beginning of World War II, Central Square was bustling with people and traffic. By this time, the city had eliminated its system of streetcars in favor of motorized buses. The downtown area was the place for shopping, with two major department stores—Strouss-Hirshberg's and G.M. McKelvey's—clothing stores like Livingstone's, and shoe stores such as Lustig's. There were four movie palaces as well: the Palace, the Paramount, the State, and the Warner. The Art Deco Central Tower, one of the last skyscrapers built in Youngstown, provides a dramatic backdrop for this photograph. Designed by Youngstown architect Morris Schiebel, the building was completed at the height of the Great Depression in 1931. (Courtesy of the Mahoning Valley Historical Society, Youngstown, Ohio.)

RAYEN HIGH SCHOOL, C. 1880. Youngstown's first public high school, the Rayen School (named for Judge William Rayen) opened in 1866. Architect Simeon Porter designed the brick building, which was constructed under the leadership of African American brick contractor P. Ross Berry. As Youngstown grew, the school was enlarged with two additions.

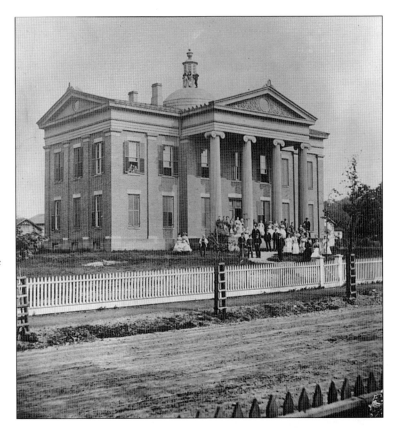

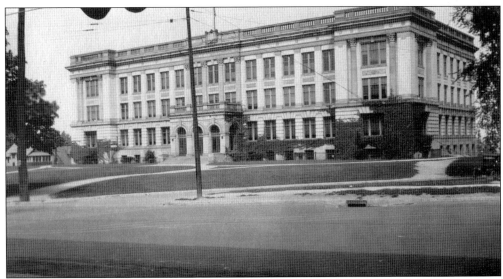

SOUTH HIGH SCHOOL. With the opening of the Market Street Viaduct in 1899, the south side of the city experienced a rapid increase in population. In 1911, the board of education opened a new high school—South High School—on Market Street. Designed by architect Louis Boucherle, the new school was state of the art for its time. Its facilities included the South High Field House, which housed athletic competitions as well as citywide band concerts and the annual spelling bee.

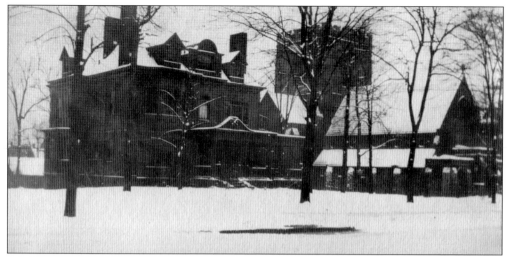

WELLES HOUSE AND ST. JOHN'S. One of the venerable institutions on Wick Avenue is St. John's Episcopal Church. The congregation formed in the 1850s but outgrew its old downtown facility by 1890. The present building, seen here, was dedicated in 1898. Just north of the church is the Thomas H. Welles house. Welles had a long career in local industry as a founder of the Youngstown Rolling Mill Company, which became part of Carnegie Steel.

YWCA. In the early 20th century, many young women sought jobs in business, education, health care, retail, and other professions. As they moved into cities, they needed a safe place to live, and the YWCA was that haven. Youngstown's Young Women's Christian Association formed in 1904 to serve the needs of young women who were making their way into the workforce.

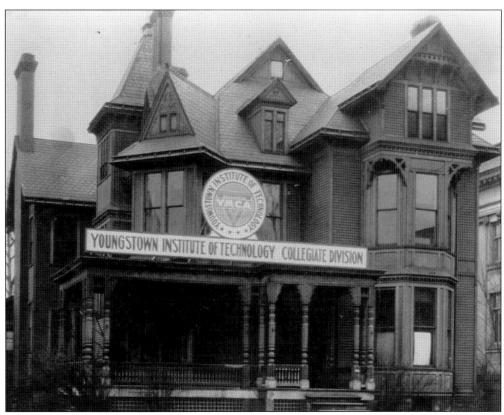

BONNELL MANSION. The YMCA of Youngstown, which had been involved in educating adults from the 1870s, began offering its first post-secondary classes in business law. It was from this that the institution of higher learning known as Youngstown State University (YSU) eventually grew. With the expansion of the YMCA's higher-education program, classroom facilities were at a premium. As Wick Avenue, the city's original Millionaire's Row, began evolving into a cultural center rather than a residential neighborhood, the YMCA took over former mansions for classroom space, such as the Bonnell residence (pictured). (Courtesy of Youngstown State University Archives.)

JONES HALL. By the late 1920s, the YMCA established a separate educational entity, Youngstown College. In 1931, the new college completed its first building constructed specifically as an educational facility, the Main Building. In 1966, it was rechristened Jones Hall after the first president of Youngstown College, Howard Jones. (Courtesy of Youngstown State University Archives.)

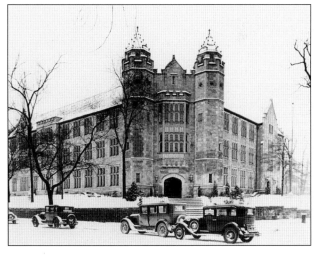

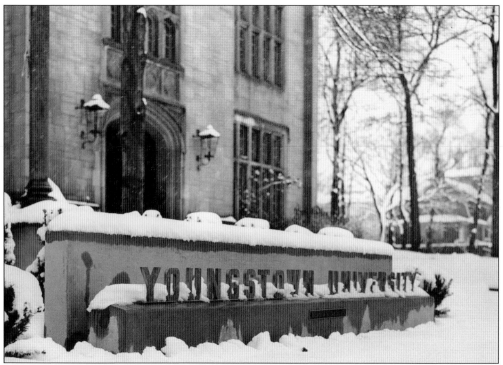

YOUNGSTOWN UNIVERSITY AND YSU. Between its founding in 1908 and its centennial celebration in 2008, the institution evolved into Youngstown University, seen above, in 1954 and Youngstown State University in 1967. YSU now enrolls about 13,000 students and boasts a large physical plant, including numerous classroom buildings, labs, athletic facilities, museums, and other amenities necessary to a modern university, as pictured below. Well-known YSU alumni include actor Ed O'Neill of *Married with Children* and *Modern Family* and astronaut Ron Parise. In its long history, YSU provided access to higher education for many, especially those from the working class who might otherwise not have had such an opportunity to improve their lives. (Both, courtesy of Youngstown State University.)

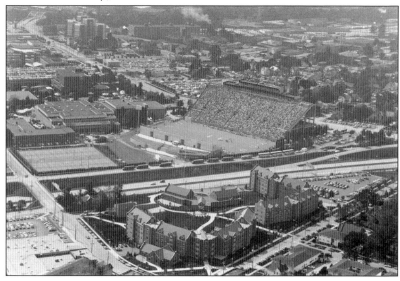

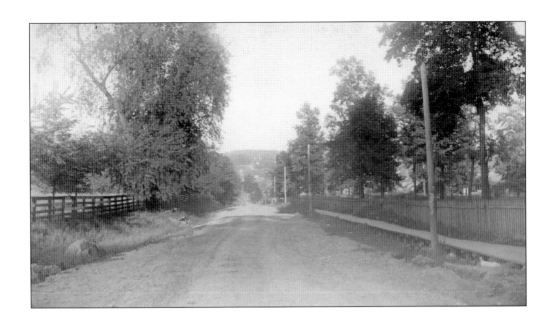

WICK AVENUE, C. 1890. In Youngstown's infancy, most people lived in or near downtown to be close to their places of work, worship, and education. By the time of the Civil War, Wick Avenue was quickly becoming the fashionable place to live. Industrialists and community leaders began building grand homes away from the commercial and industrial concerns that were located downtown and along the Mahoning River. One of Youngstown's leading families, the Wicks, gave their name to what became the city's Millionaire's Row. These two photographs show Wick Avenue in the late 19th century. Although it was home to the city's upper class, it was still largely unpaved. (Both, courtesy of John Kai Lassen.)

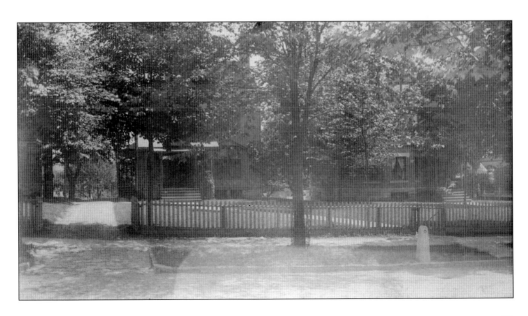

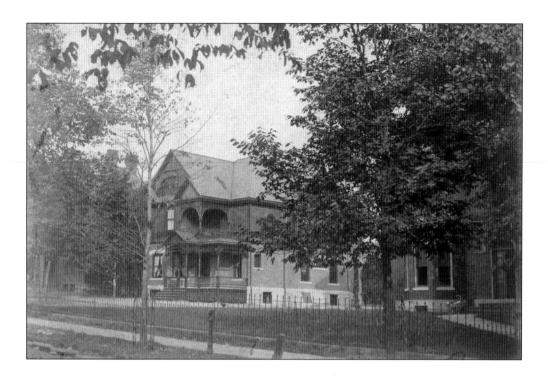

HOMES ON WICK AVENUE, C. 1890. These two views show the Wick Avenue streetscape near the turn of the last century. All of these lovely buildings are set back far from the road, giving them grand vistas. They are large structures housing elite families of the city and their servants. The fashionable neighborhood was close enough to local businesses and commerce but far enough away from the unhealthy air of the iron and steel concerns. It should be noted, however, that just below Wick Avenue to the east, the working-class neighborhood of Smoky Hollow would be platted and developed in the early 20th century. (Both, courtesy of John Kai Lassen.)

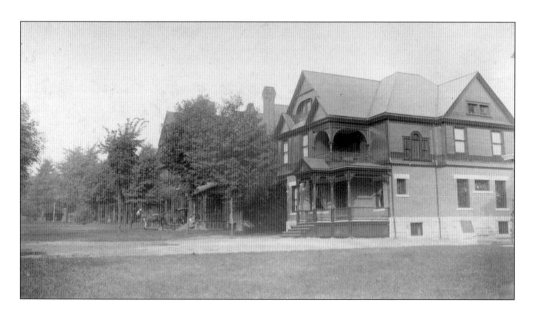

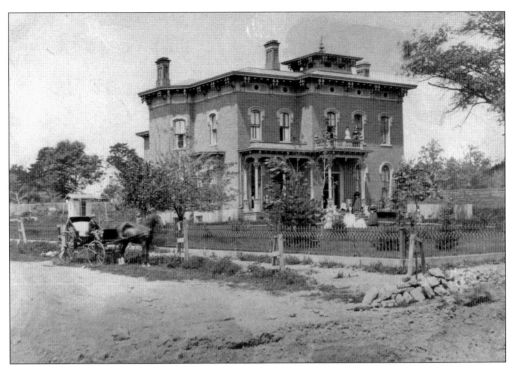

The Myron I. Arms House. At the corner of Wick Avenue and Spring Street, Myron I. Arms built this lovely house in the popular Italianate style. Myron never got to see his home completed; he died in the Civil War. The house was finished in 1866. In the early 20th century, the building was completely remodeled in the Mediterranean Revival style. (Courtesy of the Mahoning Valley Historical Society, Youngstown, Ohio.)

Charles Dayton Arms House. In 1881, Charles Dayton Arms constructed this Romanesque Revival–style sandstone mansion on Wick Avenue. Olive Arms grew up in this house and kept it after her parents died. In the 1940s, she sold the building to a Romanian congregation, and it became the new home of Holy Trinity Romanian Orthodox Church. (Courtesy of the Mahoning Valley Historical Society, Youngstown, Ohio.)

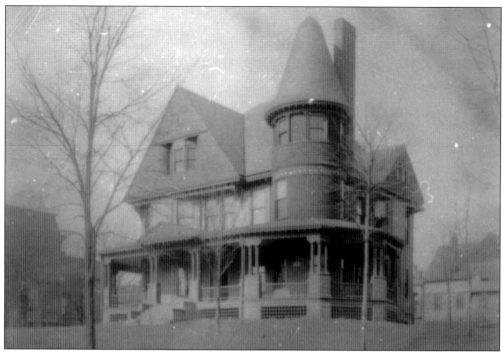

THE POLLOCK AND PECK HOUSES. Founded in 1863, the William B. Pollock Company was an old Youngstown institution. Rather than making steel, founder William B. Pollock opted to make the furnaces and other large equipment that iron and steel companies needed to function. The company was a pioneer in manufacturing blast furnaces, not only for the local market, but nationally and even worldwide. The Pollock house, pictured above, was constructed in 1893 for Mary Wick, who married William Pollock's son Porter. Youngstown architect Charles H. Owsley designed the building. Owsley also was responsible for the Peck house, seen below, which dates from 1888. George Peck was a distinguished physician, and his wife, Emeline, was the daughter of Myron I. Arms. (Both, courtesy of Mahoning Valley Historical Society, Youngstown, Ohio.)

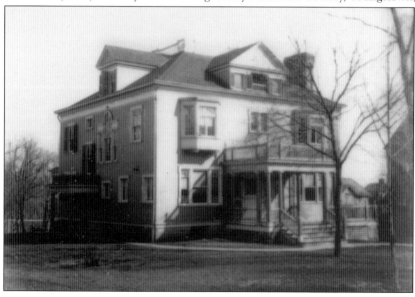

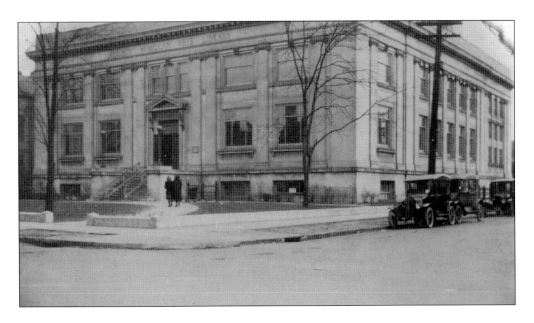

WICK AVENUE CULTURAL INSTITUTIONS. During the first three decades of the 20th century, Wick Avenue began to shift from a residential district to the city's center of arts and culture. In 1909, Charles H. Owsley and his partner, Louis Boucherle, designed the new home of the Reuben McMillan Free Library (now the Public Library of Youngstown and Mahoning County). The handsome Neoclassical Revival building seen above was partly funded by money from Andrew Carnegie, the famous steel magnate. In 1919, industrialist Joseph Butler founded the Butler Institute of American Art, seen below, the first museum to display only American artworks. Butler hired the renowned New York architectural firm of McKim, Mead & White to design the building, which was inspired by what many consider the first Renaissance building in the world, the Ospedale degli Innocenti in Florence, Italy.

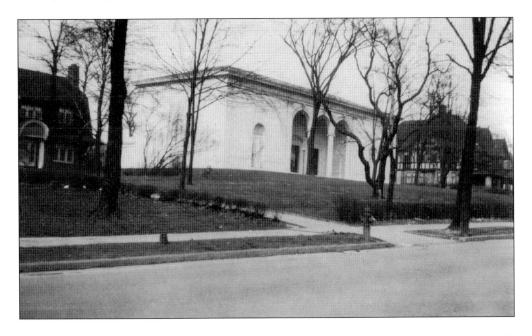

BRIER HILL. Brier Hill was originally farmland owned by George Tod, a Youngstown industrialist. In the mid-19th century, coal was discovered in the area, which led to its development as a residential district housing coal miners and workers in the nearby iron foundries and furnaces. Until the advent of modern transportation like streetcars, Brier Hill was distant from the center of Youngstown. Thus, the area developed its own commercial enterprises, schools, and churches. With the development of the steel industry in the 20th century—including the creation of the Brier Hill Steel Company in 1912—Brier Hill became a magnet for immigrants from southern and eastern Europe and boasted a particularly large Italian population.

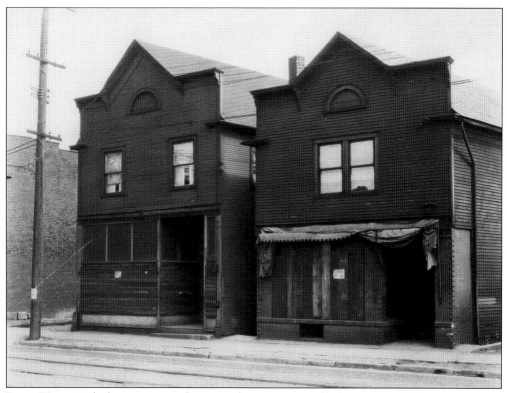

BRIER HILL. With the extension of streetcar lines to Brier Hill, the city of Youngstown absorbed the area by the beginning of the 20th century. Note the streetcar tracks in several of these images. The Youngstown Sheet & Tube Company purchased Brier Hill Steel in 1923. At the time of the merger, YS&T shot numerous images of Brier Hill, photographing housing and commercial structures. Over time, especially with the development of the freeway system, much of Brier Hill was destroyed. A few houses, St. Anthony's Church, and some commercial enterprises are all that remain of this once vibrant community.

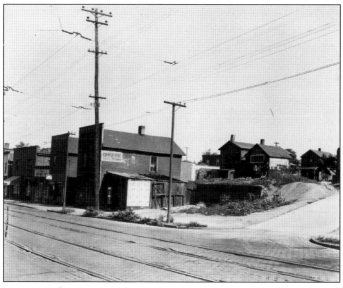

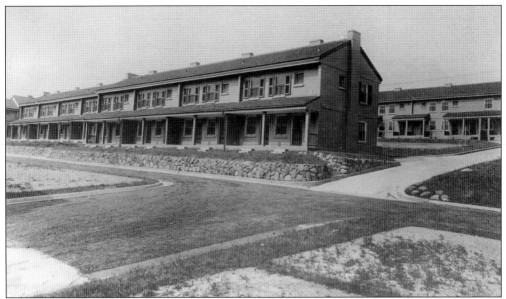

YS&T Company Housing. In the aftermath of the 1916 steel strike, the Youngstown Sheet & Tube Company sought ways to appease its workforce and forestall attempts at unionization. To that end, YS&T strengthened its welfare-capitalism program, introducing a company newsletter (the *Bulletin*), held company picnics, and embarked on the development of company housing. For the latter, YS&T established a subsidiary company—the Buckeye Land Company—to oversee the design, construction, and maintenance of the housing stock. YS&T named Barton E. Brooke as architect to coordinate design of the various plats. The plan originally called for three distinct plats: Blackburn (pictured) in East Youngstown (now Campbell) for immigrant and African American workers, Highview in Struthers for immigrants, and Loveland for white, American-born employees. A fourth plat, Overlook, located in Struthers, was composed of duplexes and was also designed for white, American-born workers.

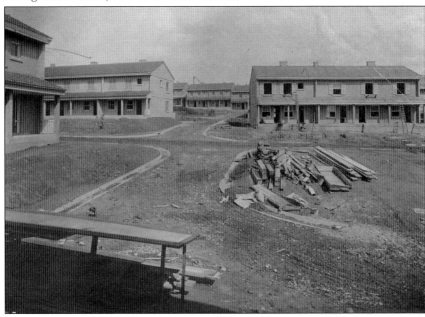

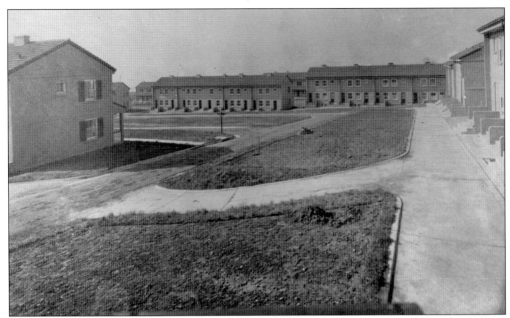

BLACKBURN PLAT. Blackburn Plat was an attractive development nicely terraced on the hillside overlooking YS&T's East Youngstown Works. The company decided that the immigrants and African Americans could not live side by side, so they segregated the housing on opposite sides of the plat, which is bisected by Jackson Street running north to south. The units had a living room and kitchen on the first floor and one or two bedrooms and a bathroom on the second floor. The basement, which had a separate entrance, contained a shower, so the men coming home from work would not track dirt through the main part of the house. The company boasted that the houses were modern in every way, with amenities like electricity, indoor plumbing, and central heating. The units were small to discourage taking in of boarders, which the company found to be "un-American" and "harmful to children."

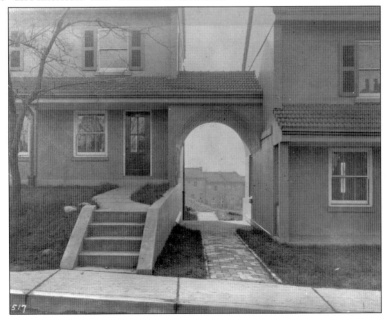

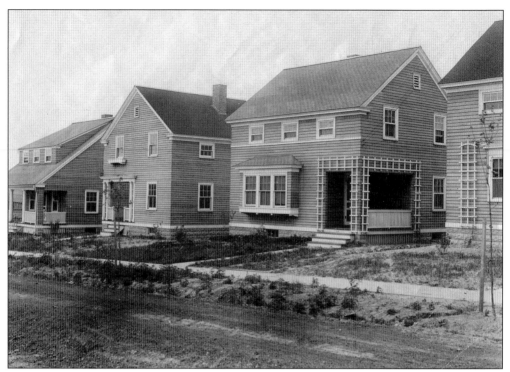

HIGHVIEW PLAT. Like many other companies, Youngstown Sheet & Tube's management believed that people who owned their own homes were more stable and reliable than those who did not. YS&T provided immigrants that it believed to be "good company men" with an opportunity to buy a detached, single-family home in nearby Struthers. These houses cost about $3,000–$5,000, which was in line with similar housing during that period. When the plat was first developed, potential residents could only purchase a house. Within a year, the company began renting the homes as well. No reason for this change in policy was given. These houses, like the row houses in Blackburn, had all the modern conveniences.

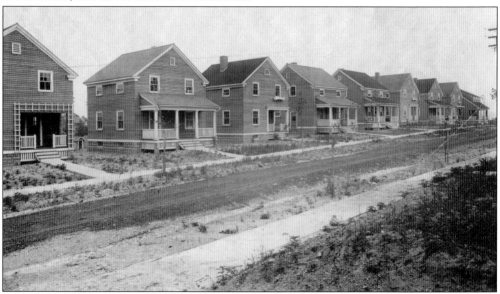

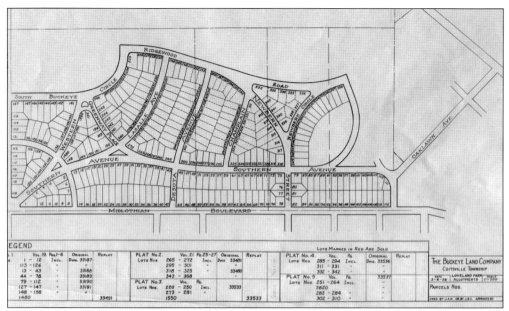

	Vol.19 Pgs.1-6	Original Dwg.33187	Replat	PLAT No.2 Lots Nos.	Vol.21 Pg.25-27	Original Dwg.33481	Replat	PLAT No.4 Lots Nos	Vol. Pg.	Original Dwg.	Replat
1 – 12	Incl.			265 – 272	Incl.			285 – 294	Incl.	33536	
113 – 126	"			295 – 301	"			311 – 331	"		
13 – 43	"	33188		318 – 325	"	33480		332 – 342	"		
44 – 78	"	33189		343 – 358	"			PLAT No.5 Lots Nos.	Vol. Pg.	33537	
79 – 112	"	33190		PLAT No.3 Lots Nos.	Vol. Pg.			251 – 264	Incl.		
127 – 147	"	33191		220 – 250	Incl.	33533		2820			
148 – 158	"			273 – 281	"			282 – 284	"		
1480		33491		1550			33533	302 – 310	"		

Lots Marked in Red Are Sold

The Buckeye Land Company
Coitsville Township
Loveland Farm Allotments Scale 1"=200'
Date 3-6-28
Parcels Nos.

LOVELAND FARMS HOUSING. Loveland Farms, bounded by East Midlothian Boulevard, Poland Avenue, Powers Way, and Walton Street, was composed of detached, single-family houses meant for sale to white, American-born YS&T employees. While many of the houses in Loveland appeared identical to those in Highview, the interiors contained different finishes and materials, making it more costly. Note the curvilinear streets; 20th-century urban planners felt that getting away from the traditional city grid plan gave a more parklike environment to neighborhoods like Loveland Farms. Loveland houses cost between $5,000 and $7,000. The image below is Loveland under construction on Southern Avenue, which was renamed Mount Vernon Avenue.

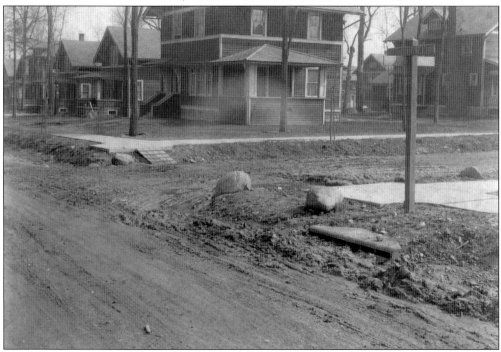

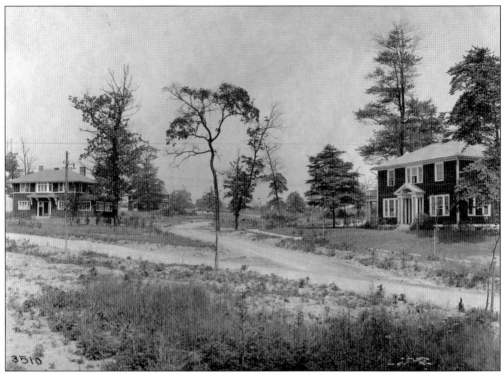

LOVELAND FARMS. In both Loveland and Highview, Youngstown Sheet & Tube, through the Buckeye Land Company, made mortgages available for those who wished to purchase a house. Loveland also had its own school, the Buckeye School, for grades one through eight, as well as its own post office substation. The company also encouraged a family atmosphere among Loveland and Highview residents. There were social clubs, gardening contests, sporting events, and other free entertainment. Both plats also had their own column in the *Bulletin*, where one of the residents (usually a woman) shared news about what was happening in the neighborhood.

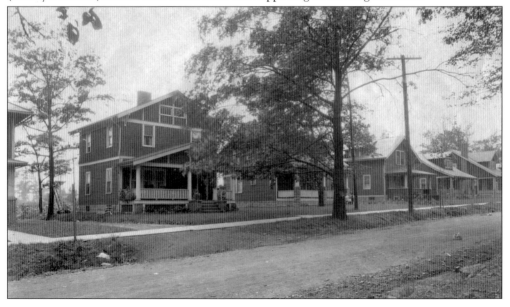

GILLIES AND PURNELL HOUSES.
In contrast to the worker housing of the Youngstown Sheet & Tube Company, the company owners lived in grand mansions. H.B. Gillies, a Sheet & Tube executive, lived in what can only be termed an estate on the outskirts of the city of Youngstown. The grand residence can be seen above in the 1930s, when he hosted an all-day party for company management and their spouses. Despite the fact that Frank Purnell was president of Sheet & Tube, his house, pictured right, on Tod Lane was not quite on the same scale of Gillies's mansion. Tod Lane, which is on the city's north side, was developed in the early 20th century. With the more widespread use of the automobile, the elite were able to move farther away from the center of the city.

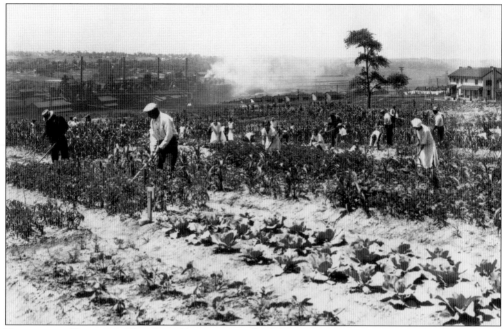

DEPRESSION GARDENS. The Great Depression, which began in 1929, was especially disastrous for one-industry towns like Youngstown. At the depths of the Depression, area steel mills operated at only about 25-percent capacity. In order to help its employees, Youngstown Sheet & Tube provided not only the land for gardens, but the seeds as well. While only a stopgap in the economic calamity facing the nation, it was at least some measure of help. These two images show one of those Sheet & Tube gardens and the steep terrain of the Mahoning Valley. Worker houses line the streets, and YS&T can be seen in the distance.

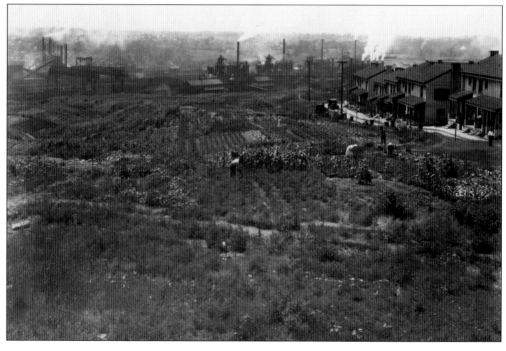

Five

STEEL GOES TO WAR

In the 20th century's two world wars, steel communities like Youngstown played an important role, from providing the material for war items to sending their youth to fight for their country. Although the majority of Americans opposed entering both conflicts, circumstances eventually led to intervention. Once the nation committed itself to fight for democracy, Americans rallied around the cause. In both wars, steel companies sponsored rallies to buy Liberty Bonds (World War I) and War Bonds (World War II), which helped finance the war effort. Everyone was encouraged to do their part. As the men went off to war, they were replaced by women, even in heavy industry. During World War II, thousands of Rosie the Riveters donned protective clothing, picked up their tools, and served their country in vital war industries. Without the steel industry and its people, the United States would not be, as Pres. Franklin Delano Roosevelt stated, the "arsenal of democracy."

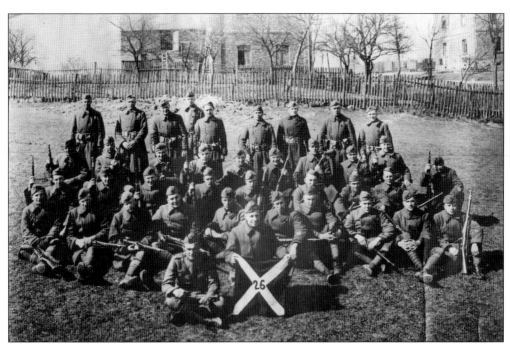

SOLDIERS AND STENOGRAPHERS. World War I broke out in August 1914. Americans, for the most part, did not want to get involved in what they believed was largely a European conflict. There was also no overwhelming consensus as to which side the United States should support. The German Americans formed a significant part of the US population, which partly played into this ambivalence. The unrestricted submarine warfare that Germany engaged in, especially against neutral shipping, helped to turn the tide of American public opinion. After Germany resumed sinking neutral vessels in 1917, the United States declared war on Germany and its allies in April of that year. Many steelworkers in Youngstown responded to the call to arms, like the soldiers seen above. Women, who also wanted to do their part, began entering the workforce in greater numbers, like the stenographers for the city of Youngstown seen below.

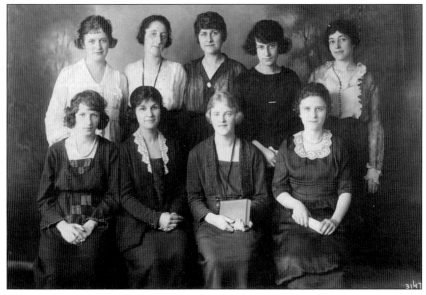

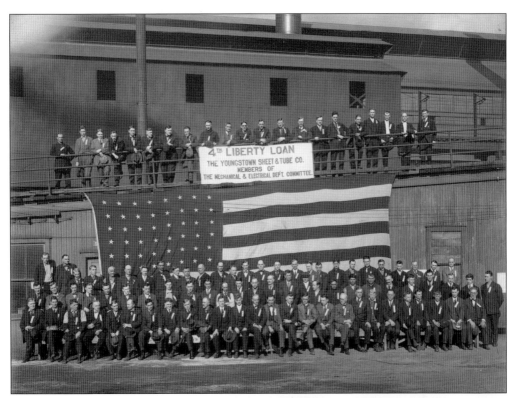

LIBERTY LOAN RALLY. One way the United States financed its role in World War I was through Liberty Loans. These functioned much like the modern Savings Bond, with people purchasing bonds that could be redeemed at face value. The image here is of the fourth Liberty Loan drive at a rally held by the Mechanical and Electrical Department Committee of Youngstown Sheet & Tube.

L.J. CAMPBELL AND MARY PLUMMER CLEMENCEAU. During the war, James A. Campbell, as director of the American Iron & Steel Institute, was responsible for the allocation of steel tubular products to the Department of War. For his work, he was honored with a citation from the French Legion of Honor, which was presented to him by Mary Plummer Clemenceau, wife of French prime minister Georges Clemenceau. Campbell's son Louis is seen here with Mary.

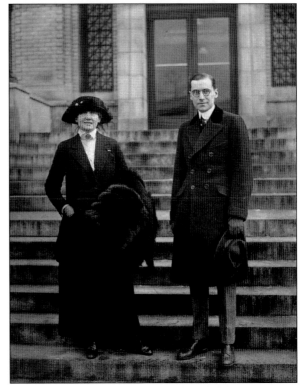

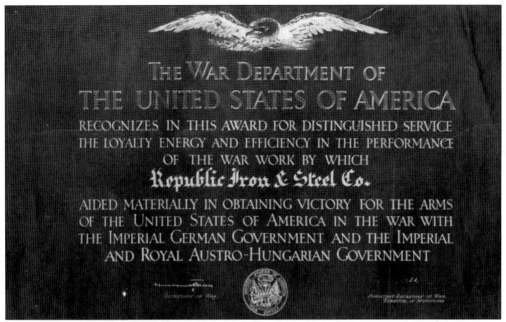

WAR SERVICE CERTIFICATE. At the end of the war, the Republic Iron & Steel Company received this commendation for its "loyalty energy and efficiency in the performance of war work . . . aided materially in obtaining victory for the arms of the United States of America in the war with the Imperial German Government and the Imperial Royal Austro-Hungarian Government."

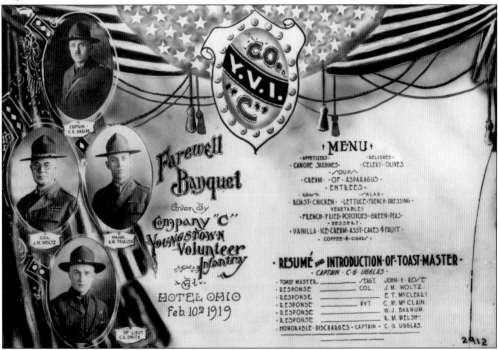

FAREWELL BANQUET. Company C of the Youngstown Volunteer Infantry Unit, which served in World War I, held a farewell banquet as they disbanded the unit. It took place at the Hotel Ohio (later the Pick-Ohio Hotel) on Boardman Street in Youngstown on February 10, 1919.

Jas. J. Dignan. Jno. C. Stroup. John S. Hobaugh. John L. Linn.

We Cherish Their Memories

Records completed up to this time show that when our country called on her sons to defend the national honor more than 2,000 workers in the Sheet & Tube plant laid down their tools, said goodbye to their friends and went into camp and field. The number was undoubtedly larger, but many enlisted without leaving their enlistment record for the roll prepared by the Safety Department.

Sgt. Geo. E. Price.

Of these boys, twenty-three were destined to make the supreme sacrifice. They are heroes, every one of them, and we reverence their names and cherish their memories. As rapidly as possible it will be our privilege to render to them a slight tribute by printing their records and their pictures (if these can be obtained). Eventualy all of these names will find a place on the beautiful monument in Campbell Park. Ten photos

are reproduced on this page, with the name of the hero beneath each. The records of service are briefly given below.

Private James R. Dignan, of the Sheet Mill, was killed October 21, 1918, by a machine gun bullet while making an advance in the battle of the Argonne, and was buried in the Argonne battefield. He was a member of Co. G, 59th Reg., 4th Div.

Private John W. Greek of the Sheet Mill, was gassed in France—in what battle it is not known. He was later brought back to Ellis Island and died August 15, 1918. Private Greek was a member of Co. D, 166 Reg. Inf., 42nd Rainbow Div.

Private John S. Hobaugh, also of the Sheet Mill, was killed by a bursting shell September 29, 1918, in the battle of the Argonne. He and two others were bringing up ammunition when struck by the shell and all three were killed. He was a member of Co. D, 11th Machine Gun Bn., Div. unknown.

Private James Jackson of the Tube Mill, died of pneumonia October 25th, 1918, at Camp Sherman. He was with 25th Co., 7th Tr. Bn., 158 Depot Brigade, Camp Sherman, Ohio.

Private Phillip Koustar, of the Tube Mill, was discharged from the United States Army October 17, 1917, on account of ill health. On November 18, 1918, he died at the City Hospital, Youngstown, Ohio, of Spanish Influenza. Private Koustar was a member of 17th Co., 5th Bn. 155th Depot Brigade, Camp Lee, Va.

Private John L. Linn, Skelp Mill Mechanical Department, who was a member of Co. A, 112th Inf. 28th Div., died of pneumonia April 6, 1919, at LeMans, France, and was buried in United States Cemetery at LeMans.

Private George W. Metzler, of the Sheet Mill, was wounded July 1, 1918, while fighting in the mountains of Haiti. He died of pneumonia January 7, 1919, at San Domingo, West Indies. Private Metzler was a member of 3rd Prov Reg. 113th Co., U S. Marine Corps.

Corp. Miles Shea.

First Sergeant George E. Price, of the Sales Department, died of pneumonia on October 3rd, 1918, at Camp Lee, Va. He was a member of Co. 11, 3rd Tr. Bn., 15th Depot Brigade.

Corporal Miles Shea, of the Sheet Mill, died of pneumonia April 18, 1918, at Camp Sheridan, Ala. He was a member of 135th Machine Gun Bn., 37th Div.

Private John C. Stroup, of the Rod and Wire Department, was killed in the battle of St. Mihiel, September 12, 1918. He was a member of Co. B, 11th Reg. Inf. 5th Div.

 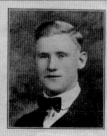

John W. Greek. Geo. W. Metzler. Jas. Jackson. Philip Koustar.

COMMEMORATING THOSE WHO DIED. The Youngstown Sheet & Tube Company honored its dead with a full-page article in the newly minted company newsletter, the *Bulletin*, which began publication in 1919. A companion article in the same issue featured Sheet & Tube employees whom the company welcomed back after the war. Of the 2,753 employees who entered the service, there were 30 fatalities. When the United States entered the conflict in 1917, it referred to itself as an "associate power." At the time, the Europeans had been bogged down in horrendous trench warfare for nearly three years. While the United States lost over 116,000 military personnel and over 200,000 Americans were injured, Europe suffered far more devastating losses. There were a total of over nine million military deaths and almost another million direct civilian deaths. This does not count the numbers lost to Spanish influenza, which broke out in early 1918.

ELEANOR ROOSEVELT VISITS YOUNGSTOWN. World War II ignited in Europe when Germany attacked Poland on September 1, 1939. As in the earlier conflict, Americans were determined to remain neutral. After Pearl Harbor on December 7, 1941, all of that changed, and the United States soon mobilized its great industrial might for the war. When the war broke out in 1939, First Lady Eleanor Roosevelt, seen here, paid a visit to the Youngstown Sheet & Tube Company.

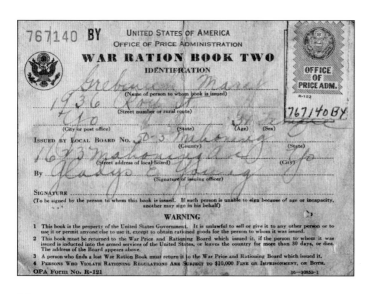

WAR RATION CARD. The United States established the Office of Price Administration during the war to control prices of products and even engaged in rent control. People were also issued ration cards, seen here, allowing them controlled amounts of staples like flour, sugar, and butter. The idea was that these foods were essential to the armed forces, and people at home had to make sacrifices for the war effort.

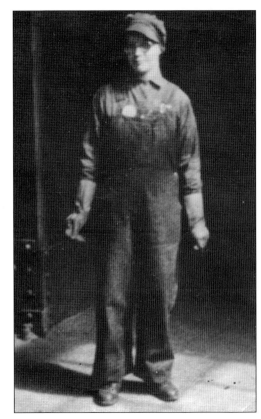

ROSIE THE RIVETER INSPECTING PIPE. The iconic image of World War II was Rosie the Riveter, representing the many women who opted to serve their country, especially in vital industries like steel. Being a "Rosie" meant dressing in appropriate clothing and wearing heavy protective gear. In the steel industry, one of the many jobs women did was inspecting pipes, as seen here. One woman described her job inspecting welds, "They used to make the things that would go on a tank, the treads. Then we had to inspect for cracks . . . They put you right on the tank as soon as you got there. They teach and show you how you have to chip the weld . . . and clean it and look for cracks. And if you found a crack, you'd mark it with a crayon, C. and if it wasn't welded right you had to put something else on it and it would be rejected."

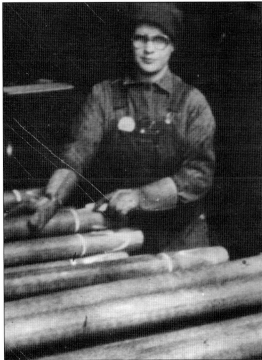

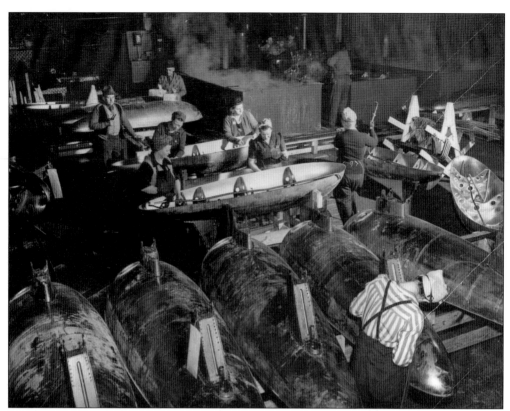

WOMEN AT YOUNGSTOWN STEEL DOOR. The Youngstown Steel Door Company originally produced doors and sides for railroad boxcars, beginning in 1924. Prior to that, most boxcars were made out of wood. As with many industries, they were forced to retool and produce armaments of war. This particular company manufactured gas tanks and bomb casings. Other local concerns also began producing war goods. General Fireproofing, which made steel office furniture before and after the war, made war items like airplane landing mats. The steel industry provided the necessary tubes, sheets, conduits, rods, and wires vital for all the war industries.

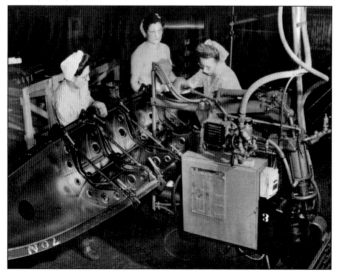

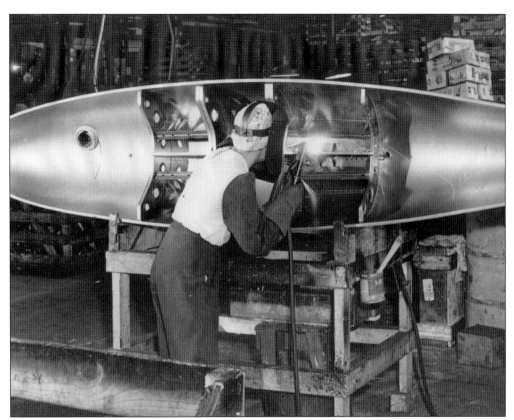

WOMEN AT WORK. Many women worked at Youngstown Steel Door. Above, a woman in seen welding; below, another employee is cleaning out the casing. As women made their way into "men's jobs," they were not necessarily welcome. Many of the men still on the job were not convinced that females could do the difficult work in industry. The women soon proved that they could handle manual labor and work as hard as any man. For the most part, however, they were not placed in supervisory positions. Men still held those jobs. Equal pay was also not the norm; women were still paid less then men, even if they did the same job.

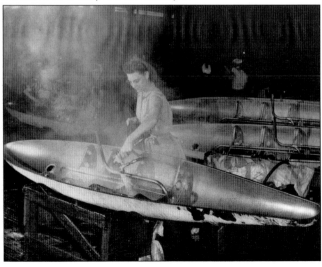

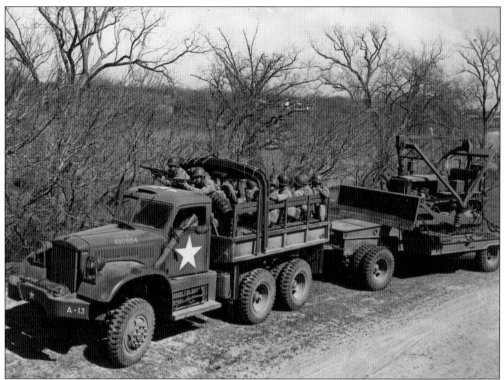

ARMY TRANSPORT AND AIRPLANE. Local industries were very proud of the products they provided for the war effort. Above, a US Army truck hauls soldiers and equipment. What interested local companies was the equipment, not the vehicles. The image below is meant to show not the airplane, but the landing mats instead. Several Youngstown firms, such as Truscon Steel and General Fireproofing, produced portable airplane landing mats that were used in places like the South Pacific islands, where the sandy soil was not conducive to landing aircraft. In both cases, the manufacturer wanted to record its part in the war effort.

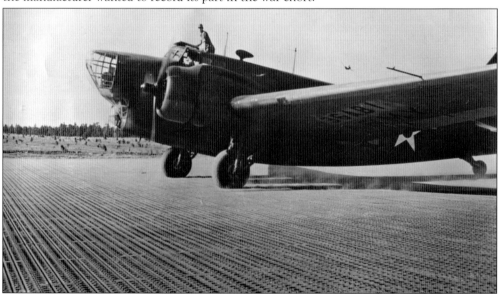

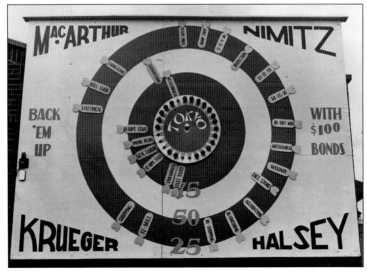

WAR BOND SIGNS. One of the ways the federal government financed the war was through the sale of War Bonds. The government issued what it named the Series E, or Defense (later War), Bond for sale to individuals. The purchaser paid less than face value of the bond, which would mature to full value in 10 years. Even schoolchildren were involved; they could purchase stamps at school for as little as 10¢ until they accumulated enough stamps to buy a bond. Businesses and communities held war bond drives, as these two signs from Carnegie-Illinois Steel's Youngstown District show. The sign above depicts the progress made in the seventh Loan Drive in 1944, indicating how much various positions in the mill contributed to date. The sign below encourages employees to buy as many bonds as possible; the focus is on the war in the Pacific.

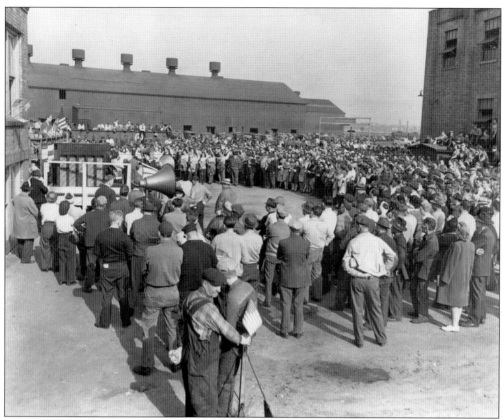

WAR BOND RALLY. In 1944, Carnegie-Illinois Steel's Youngstown District had a massive War Bond rally during the fourth Bond Drive. As can be seen from the crowds, it was a large turnout. Steel companies encouraged employees and their families to participate in such activities, and rallies like this were common throughout the United States.

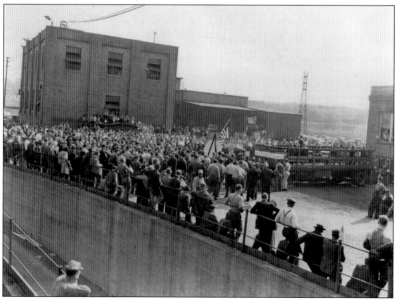

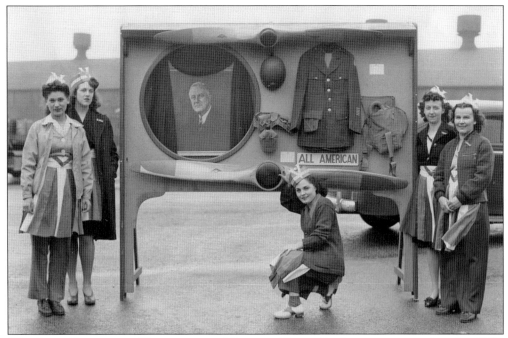

WAR BOND PROMOTION. These women of Carnegie-Illinois Steel are promoting the sale of War Bonds with their exhibit. They are, from left to right, Frances Simon, inspection; Emily Henderson, mechanical; Ann Dinard, No. 18 mill; Sally Welsh, electrical, and Helen Toth, band mills. In the case are two airplane propellers, a uniform, and a photograph of Pres. Franklin Delano Roosevelt. The exhibit was a part of the 1944 War Bond Rally.

MARLENE DIETRICH AT WAR BOND RALLY. Just as in World War I, Washington enlisted Hollywood celebrities to encourage the sale of War Bonds. The glamorous star Marlene Dietrich came to Youngstown to lend her fame to the war effort. Although she was born in Germany, Dietrich was rabidly anti-Nazi and became a US citizen in 1939. It was widely held that she sold more War Bonds than any other celebrity.

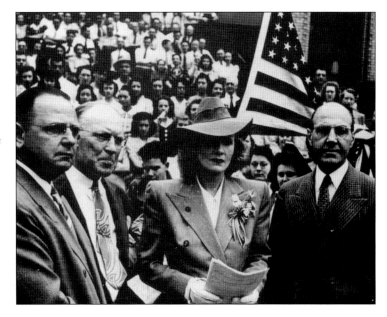

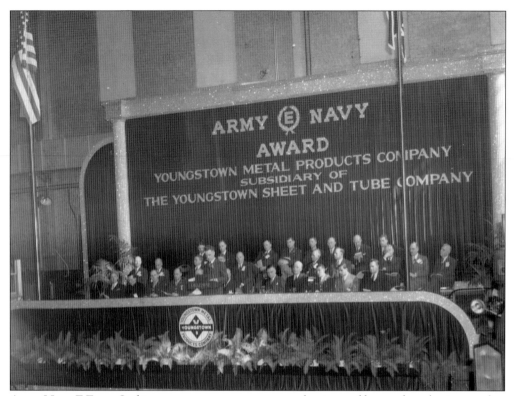

ARMY-NAVY E FLAG. Seeking a way to encourage war production and honor those businesses that had achieved excellence, the federal government initiated the Army-Navy E for Excellence Award in 1942. This occurred when the Navy-E and the Army Navy War Munitions Board merged. There was precedence for such an honor. During World War I, there had been several types of awards: the Navy-E, the Army-A, and the Army-Navy Star. Some of the criteria to receive the award included an excellent safety and sanitation record, maintenance of fair labor standards, production quality, and effective management. To maintain such high levels of production, as well as operations, the government gave additional white stars to place on the flag every six months. In 1943, Youngstown Metal Products Company, a division of the Youngstown Sheet & Tube Company, received the award. The photograph below shows the dais for management and the speakers. Representatives of the armed forces attended the event, as did all the employees.

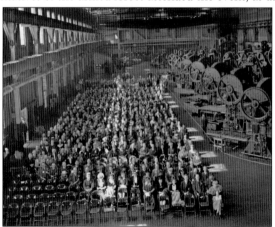

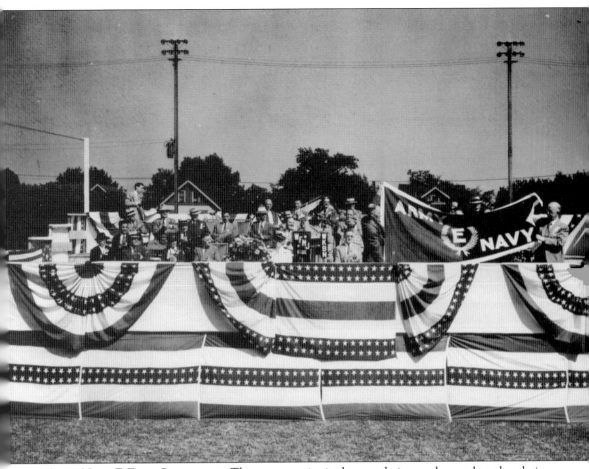

ARMY-NAVY E FLAG CEREMONIES. The company invited not only its employees, but also their families. It was a very formal event, with engraved invitations and elaborate programs. In this photograph, taken at the E Flag Ceremony at Commercial Shearing in Youngstown, the actual flag is being presented, which the company proudly displayed. Following the flag ceremony, each employee received a pin as well.

INJURED VETERAN, c. 1945. Waldo Edward Zimmerman was injured during the war. A native of Pennsylvania, Zimmerman was born in 1923. His father, Waldo Sr., was a railroad engineer. Prior to serving his country, young Waldo was an employee of Carnegie-Illinois Steel's Ohio Works. He died in Mount Pleasant, Pennsylvania, in 2004 at the age of 81.

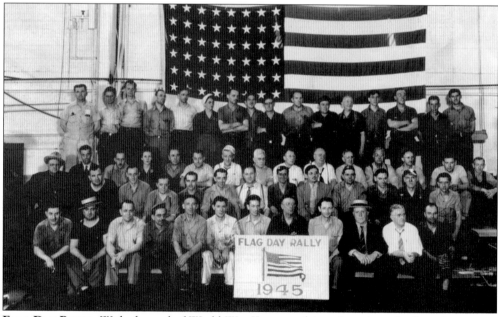

FLAG DAY RALLY. With the end of World War II approaching, Americans had much cause to celebrate. On May 8, 1945, Germany surrendered to the Allies. Although the nation was still fighting the war in the Pacific, Youngstown people held a rally on June 14, 1945, anticipating victory in the Pacific as well. That would come nearly two months later on August 15, 1945, known as V-J Day.

Six

HAVING FUN

Youngstown's people worked hard and played hard. Throughout its history, the city encompassed facilities designed specifically for leisure-time activities. Whether enjoying the natural beauty of Mill Creek Park, riding the roller coaster at Idora Park, engaging in sporting activities, going to the movies, or catching a live performance, Youngstown offered opportunities to do it all. Not only did it have many kinds of entertainment venues, with the development of its electric streetcar and interurban system, it also had ways to ensure that the people could get to more remote sites. As with nearly every other aspect of life in this industrial town, the steel industry often sponsored activities outside of the workplace for its employees and their families.

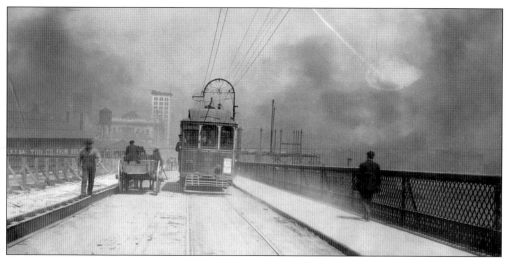

TROLLEY ON BRIDGE. Youngstown electrified its streetcar lines in the 1890s. At the same time, the city wanted to build a modern bridge on Market Street to connect the south side with the rest of town. The Park & Falls Street Railway Company, which was chartered in 1893, agreed to fund the new span if it was guaranteed the right-of-way over the bridge. When the line opened in 1899, the company sought ways to increase ridership. At the end of the line, Park & Falls opened a small amusement area named Terminal Park. With this attraction, later renamed Idora Park, the Park & Falls line became the most profitable in Youngstown. These two images show a Park & Falls car on the Market Street Bridge. Note the sign on the image below; it is advertising a program at the Park Theater in downtown Youngstown.

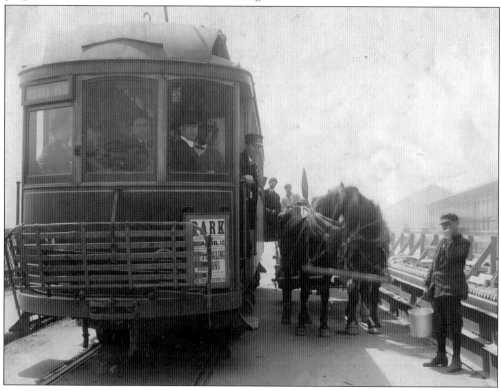

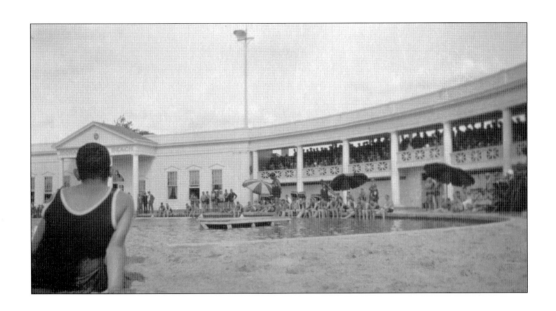

IDORA PARK POOL. When Idora Park opened in 1899, it had only a few modest attractions. Within 10 years, it had a roller coaster, dance hall, carousel, and even a summer stock theater. Park advertising referred to it as "Youngstown's Million Dollar Playground." In 1924, Idora opened its own swimming pool, seen in these images. The two-story, semicircular bathhouse is designed in the popular Georgian Revival style. Park management reported that the pool had water that was clean enough to drink and that it was thoroughly filtered every 24 hours. In 1945, Idora closed the pool, supposedly to decrease the risk of the facility becoming a lightning rod for civil rights issues. They paved the pool over and opened Kiddieland on the site, although the bathhouse remained in use as a picnic pavilion.

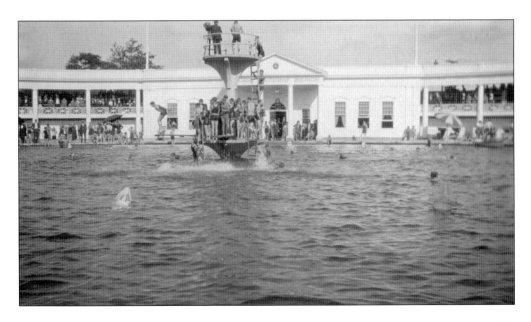

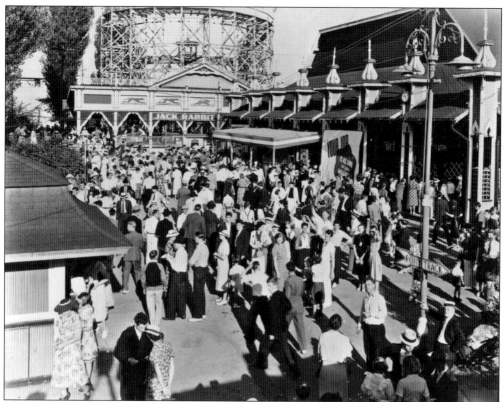

LABOR DAY, 1939. Idora Park became a regional venue, attracting people of all classes and ethnicities from around the area. Many organizations, including local companies, labor unions, and ethnic groups, held their picnics at the park. By 1930, the Mahoning Valley's diverse ethnic groups each had their own "day" at Idora. The African American community, however, was relegated to one day a week for many years. Nonetheless, this was different from many other parks, which totally excluded African Americans. These two images are from the 1939 Labor Day picnic held by the Youngstown Sheet & Tube Company. Above, crowds mill around the entrance to the ballroom (right), and the loading area of the Jack Rabbit roller coaster (center). The image below shows a YS&T baseball team posing for the camera, with the Jack Rabbit's back hill behind them.

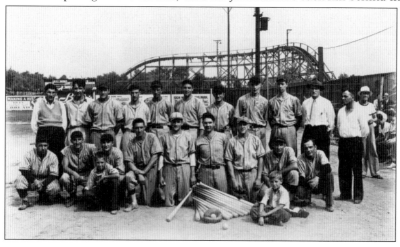

MILL CREEK PARK. Founded by Volney Rogers in 1891 as one of the first municipal parks in Ohio, Mill Creek Park is still one of the Mahoning Valley's great treasures. Rogers, who engaged the services of Charles Eliot, an associate of the great landscape architect Frederick Law Olmstead. Rogers believed that the natural beauty of the park would be beneficial for all the citizens of the area, no matter their class. Indeed, like Olmstead, he believed parks were ways, especially for working-class people, to "vent . . . aggressions" in a healthful manner. These two scenes show one of the park's recreational lakes.

MILL CREEK PARK DAM. The dam at Lake Cohasset in Mill Creek Park is seen in this image. The dam helped to maintain the waters of the Mill Creek that gave the park its name and thus formed Lake Cohasset, which was used for boating, fishing, swimming, and other sports.

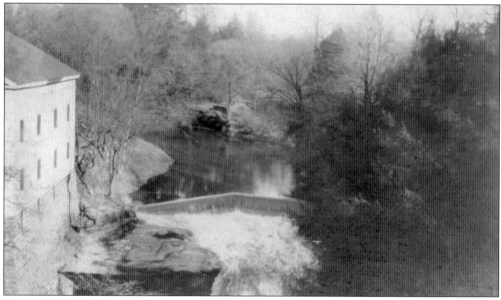

LANTERMAN'S MILL AND FALLS. Lanterman's Mill on the Mill Creek dates back to the mid-19th century. It started out as a gristmill and, over time, was used for other functions, including storage of boats and a dance hall. The falls provided the power for the gristmill and is still part of Mill Creek Park's attractions.

BRIDGES IN MILL CREEK PARK. While Mill Creek Park's natural beauty enticed visitors, Rogers enhanced the experience by designing trails and bridges. Park designers wanted to preserve the natural beauty of the site but also needed to provide visitors with byways and infrastructure so they could easily navigate the space. In the image above, two children stand on what is known as the High Bridge. This span was built in 1883, eight years prior to the establishment of Mill Creek Park. The image below is a more artistic shot. In it, the photographer attempts to capture the reflection of the stone bridge in the lake below. Both of these photographs probably date from the 1920s.

MILL CREEK PARK STONE BRIDGE. The stone bridge arches its way gracefully across Lake Glacier in the park. This particular span is one of the oldest in the park, and visitors can still enjoy its architectural splendor. It has been modified over time to allow for automobile traffic, but the stones remain in place.

PIONEER PAVILION. One of the favorite party places in Mill Creek Park is Pioneer Pavilion. Daniel Heaton originally constructed it in 1821 as a woolen mill and later built a blast furnace next to it. In 1850, after about 20 years of service, the furnace was abandoned. The building was remodeled in 1893 for use as a picnic pavilion.

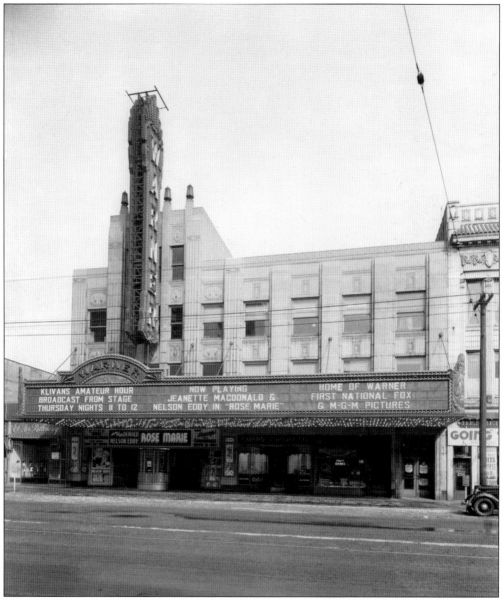

WARNER THEATER. One of Hollywood's great motion picture studios can trace its origins to Youngstown. Benjamin and Pearl Warner immigrated to the United States in the 1880s from Poland. Although he started as a shoemaker, Benjamin later operated a meat market in the downtown area. However, four of their sons—Harry, Sam, Albert, and Jack—were entranced by the newly developed motion picture and began showing films at Idora Park. The brothers decided that there was more money to be had in making pictures, so they formed their own studio, known as Warner Brothers. Although they started in New York, they eventually moved the production operation to Hollywood. The studio struggled through the late teens but became a major facility when the brothers took a chance and released the first talking picture, *The Jazz Singer*, in 1927. Four years later, to honor their parents and brother Sam (who died in 1927), the surviving Warners built a lovely movie theater in what they considered their hometown, Youngstown. The Warner Theater, seen here in 1936, was designed by noted theater designers Rapp & Rapp.

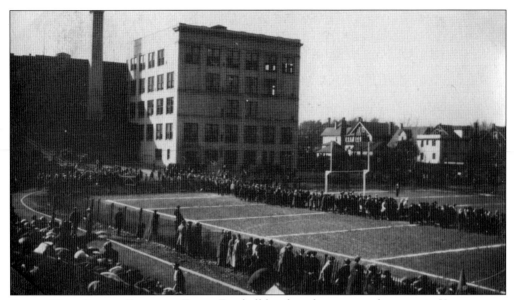

SOUTH HIGH SCHOOL FOOTBALL FIELD. Football has long been a popular sport in Youngstown. South High School's football field was the scene of many athletic contests and other events, such as graduations, throughout its history. The facility is seen here during a special event in the 1920s.

YOUNGSTOWN COLLEGE FOOTBALL. In 1938, Youngstown College fielded its first football team, thus beginning a long tradition of excellence in that sport that continues through today. Marilyn Chuey, daughter of Youngstown College president Howard Jones, commented on the enthusiasm the city had for its new home team, stating that there were probably 10,000 people at its inaugural game. (Courtesy of Youngstown State University Archives.)

114

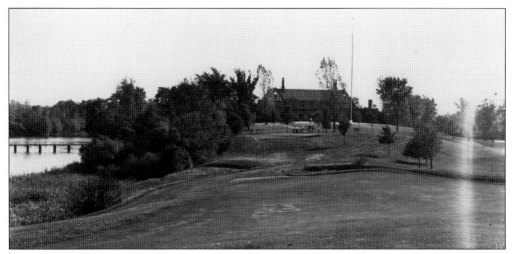

YOUNGSTOWN COUNTRY CLUB. While many of Youngstown's recreational offerings were open to all, the elite still maintained their own special places. In 1898, the Youngstown Country Club opened on the city's north side near Wick Park. Within a few short years, the club had to move, as the land was needed for residential development. The country club moved farther north and eventually located in Liberty Township, north of the city of Youngstown.

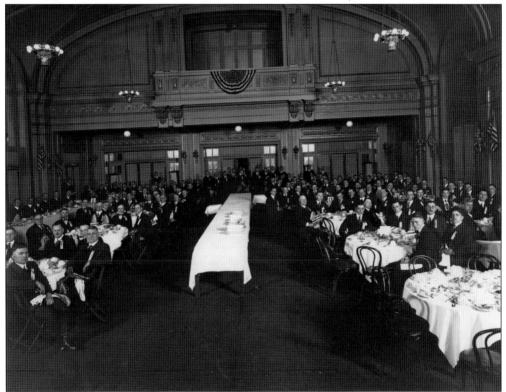

YOUNGSTOWN SHEET & TUBE COMPANY BANQUET. The Youngstown Sheet & Tube Company sponsored many events for some of its employees. Around 1920, it held a banquet, possibly for its workers who served during World War I. Note that all of those present are male, so it is evident that only certain employees were invited to participate.

DANCE. About the same time as the banquet, Sheet & Tube held a dance for its employees in a local community hall. Note the paper many of the women are holding; that is their dance card, which allowed the men to sign up for each dance with the woman of his choice.

PICNIC AT CAMPBELL PARK. Sheet & Tube, like many companies, held picnics for its employees. Campbell Park, located near the main YS&T facility, was a favorite spot for such outings. In this image, the picnickers surround the band. The pavilion was used for dancing, which cost a nickel to participate in.

116

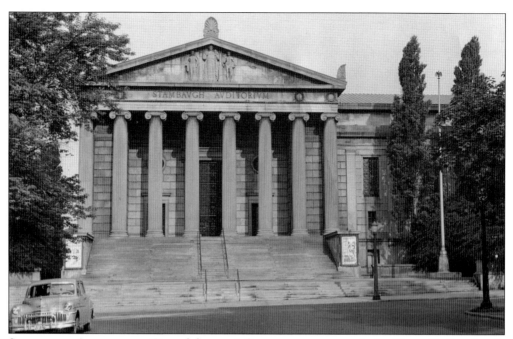

STAMBAUGH AUDITORIUM. One of the area's finest concert venues is the Henry R. Stambaugh Auditorium, pictured above, which was located on Youngstown's near north side, across from Wick Park. Constructed in 1925, the building was designed by the New York architectural firm of Helme & Corbett in the popular Neoclassical Revival style. In 1919, community leader Henry H. Stambaugh left $1.5 million in his will for the construction of the building that bears his name. For many years, the institution that is now Youngstown State University has held important events at the facility. For example, the annual Greek Sing, which is performed by the school's fraternities and sororities, is held here. In the image below, young men and women in the 1930s participate in the spring formal. (Above, courtesy of Stambaugh Auditorium; below, courtesy of Youngstown State University Archives.)

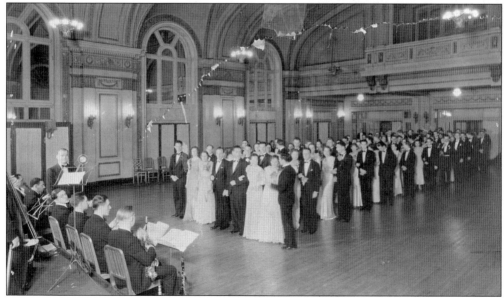

MINSTREL SHOW AND CONCERT. Many Youngstown Sheet & Tube events were held in Stambaugh Auditorium, which boasts a 2,553-seat concert hall with outstanding acoustics, a 9,700-square-foot grand ballroom, and the Anne Kilkawley Christman Memorial Hall. In its long history, Stambaugh Auditorium has hosted classical and popular concerts, commencement ceremonies, operas, plays, and numerous private events. In the 1938 photograph above, Youngstown Sheet & Tube employees present a minstrel show at the venue. Over the years, the company also held concerts performed by its own YS&T orchestra and chorus, all composed of employees. One of those concerts is seen below.

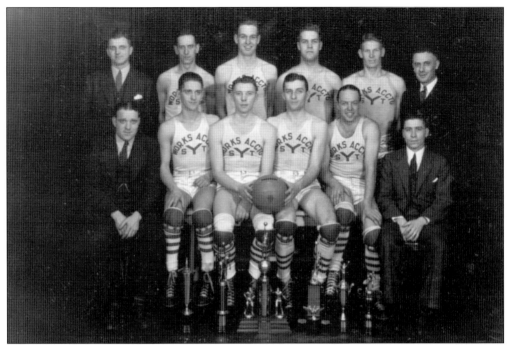

MEN'S BASKETBALL AT YS&T. For many years, the Youngstown Sheet & Tube Company sponsored athletic teams in several sports. The men's teams were usually divided by department. For example, the Works Accounting Team, seen above, might play the Boiler Team, pictured below. There were even occasions where they might play teams from other local companies. Industrial teams were not uncommon. Many large companies fielded such teams in different sports, and competition was tough. It was not unheard of for companies to hire employees based on their athleticism rather than for their skills as workers, and it was also believed that participation in sporting activities helped to build teamwork.

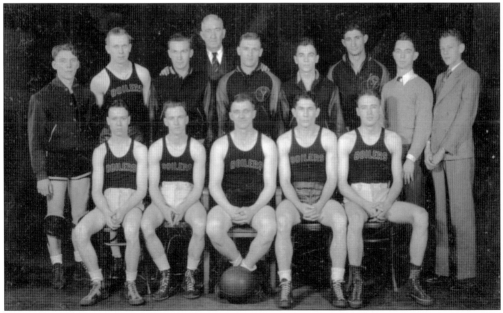

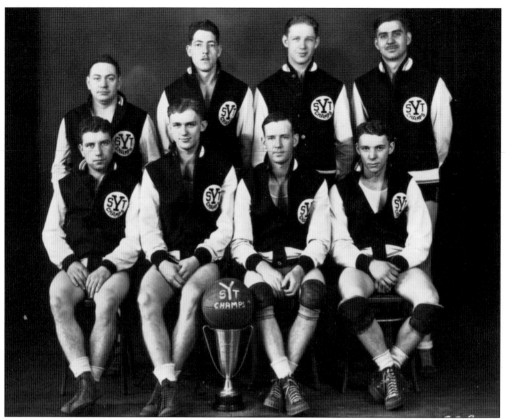

Basketball and Bowling Teams. Youngstown Sheet & Tube's Rod and Wire basketball team, seen above, was the champion of the plant around 1930. Below, bowling was an activity that seemed particularly well suited to industrial communities. The Mahoning Valley had a number of bowling alleys, which became centers of social activity. It was also a sport for people of all ages, which contributed to its popularity. Youngstown Sheet & Tube also sponsored a company bowling team, seen here. Sponsorship of athletic teams was as much a part of a welfare-capitalism program as were efforts to improve safety, housing developments, company newsletters, picnics, dances, and Americanization programs.

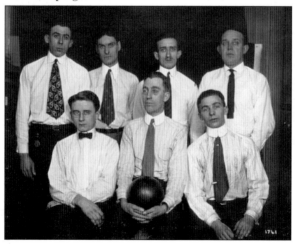

WOMEN'S BASKETBALL TEAMS. Athletics was not limited to male employees. Youngstown Sheet & Tube's female workers were encouraged to participate in athletic endeavors as well. In the early 20th century, there was a new emphasis on health and wellness for all people. Women were actually encouraged to participate in athletic activities, whether by doing calisthenics, riding bicycle, or playing sports like tennis, baseball, and basketball. In order for women to perform these activities, new articles of clothing were available specifically for athletic purposes. The two women's teams seen here are appropriately attired. These images depict women's championship teams; the one above is undated, but the one below is from 1932.

AMERICA'S PASTIME. During most of the 20th century, baseball was truly America's pastime. While basketball, football, and other sports were popular, none surpassed baseball. Youngstown itself had a history of semiprofessional teams, especially in the early 20th century. Baseball diamonds proliferated in the community, and games were well attended. The Youngstown Sheet & Tube Company fielded baseball teams for many years, even up until the late 1970s. The image above is the company's city baseball team, made up of staff who worked at the YS&T office located in the Stambaugh Building in downtown Youngstown. The team below is composed of employees from various departments.

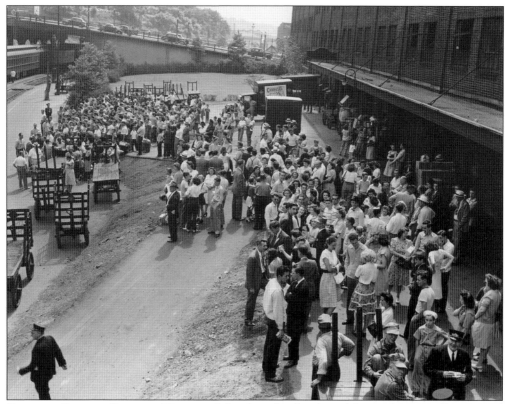

CARNEGIE-ILLINOIS STEEL ON HOLIDAY. Like the other local steel firms, Carnegie-Illinois Steel sponsored company picnics for its employees. While local attractions like Idora Park were often the scene of such festivities, sometimes out-of-town venues were also utilized. Around 1950, Carnegie-Illinois Steel planned just such an event for its staff and their families. Everyone went to the Erie Terminal in downtown Youngstown to ride to the picnic. In these two images, the large crowd is assembled and ready to go, and everyone waits in breathless anticipation to savor the smell of hot dogs, partake of the many mechanical rides, go boating on placid lakes, or just enjoy the carnival atmosphere at a pleasure park.

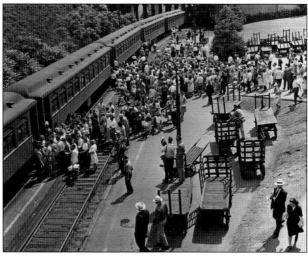

I LOVE A PARADE. Parades were—and are still—very popular with the people of the Mahoning Valley. Holidays like Memorial Day and Veterans Day were always occasions to hear marching bands, enjoy the many unique floats, and generally partake of the celebratory atmosphere. Below, the people of Youngstown not only celebrate the nation's birthday on July 4, 1919, but also the end of the World War I eight months earlier. Youngstown State University annually holds a homecoming parade through the streets of downtown. Below, the float plays off the theme, "Keys to Our Future." This 1958 parade celebrated the 50th anniversary of what, at the time, was Youngstown University.

124

HIGH- AND LOW-BROW ENTERTAINMENT. While some places of leisure were open to those of all means, in some cases, the cost of certain amusements limited participation. In the image above, James A. Campbell, former president of the Youngstown Sheet & Tube Company, celebrates his 75th birthday. Rather than the traditional cake and ice cream around the dining room table, Campbell enjoyed his day with a round of golf at the Youngstown Country Club. The image below depicts a local restaurant and store that sold Telling's Ice Cream, a popular brand in the early 20th century. A visit to the ice cream parlor on a hot summer's day was a fun activity for people of all classes.

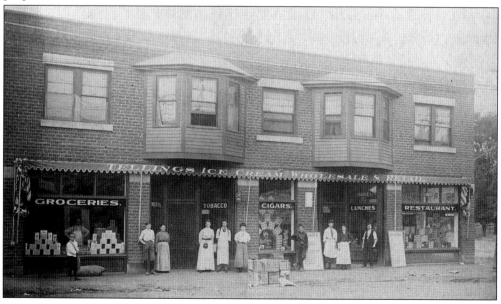

WOMEN OF YOUNGSTOWN COLLEGE RELAX. Youngstown College coeds, as they were called, found ways to enjoy their leisure time. Beginning in 1928, the school sponsored May Day activities, and students elected a "Queen of the May" to rule over the festivities. The image above depicts the first queen and her court during the very first May Day celebration. Music has had a long history at Youngstown State University. The Dana School of Music, which moved from its original home in Warren to merge with Youngstown College's School of Music in 1941, has an excellent national reputation. Music extends beyond the classroom, though, and another YSU tradition is the Greek Sing, in which fraternities and sororities show off their musical skills. The group of sorority sisters below proved victorious in the 1953 version of Greek Sing, which was then referred to as Song Fest. (Both, courtesy of Youngstown State University Archives.)

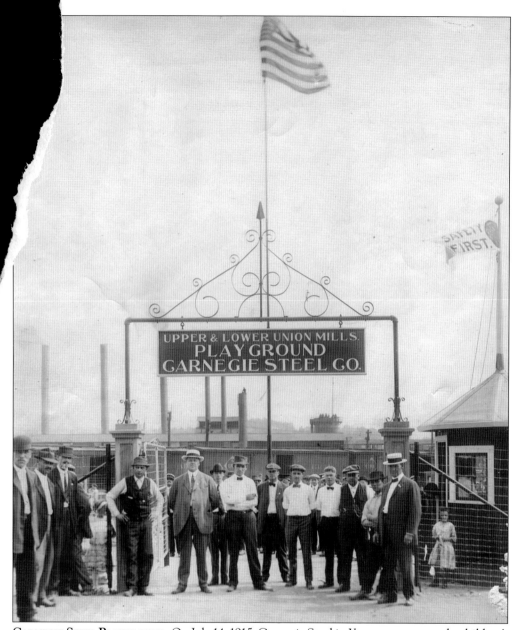

CARNEGIE STEEL PLAYGROUND. On July 14, 1915, Carnegie Steel in Youngstown opened a children's playground. The playground movement originated in the late 19th century and was a part of the agenda of many Progressives who advocated for social justice. The playground movement was closely tied to the settlement house movement. For example, Jane Addams, famous for her Chicago settlement house, Hull House, was a powerful proponent of playgrounds. Playgrounds were meant to provide a healthy alternative to life in the urban tenement houses where children could play in a safe environment. For Carnegie Steel, the playground was an expression of its version of welfare capitalism. The company believed that such amenities made for a more contented and more stable workforce. According to historian Stuart Brandes, US Steel (Carnegie Steel's parent) spent more than $22 million on welfare-capitalism programs, including playgrounds, of which there were 125 in the US Steel family.

DISCOVER THOUSANDS OF LOCAL HISTORY BO
FEATURING MILLIONS OF VINTAGE IMAGES

Arcadia Publishing, the leading local history publisher in the United St
is committed to making history accessible and meaningful through publishi
books that celebrate and preserve the heritage of America's people and place

Find more books like this at
www.arcadiapublishing.com

Search for your hometown history, your old
stomping grounds, and even your favorite sports team.

Consistent with our mission to preserve history on a local level, this book was printed in South Carolina on American-made paper and manufactured entirely in the United States. Products carrying the accredited Forest Stewardship Council (FSC) label are printed on 100 percent FSC-certified paper.

MADE IN THE